AUDREY HEPBURN

A Life in Pictures Edited by Yann-Brice Dherbier

First published in Great Britain in 2007 by PAVILION BOOKS

An imprint of Anova Books Company Ltd

10 Southcombe Street, London W14 0RA

© Anova Books Company Ltd, 2007

First published in France in 2007 by YB Editions

Text © Axelle Emden, 2007

Additional text © Yann-Brice Dherbier, 2007

Cover photography © Rue des Archives/RDA

Translation © Pavilion Books

Layout: Renaud Sauteret (sauteret@free.fr)

Editor (UK): Kate Burkhalter

Translator: JMS Publishing

A CIP catalogue record for this book is available from the British Library.

ISBN 978 186205 775 3

Printed and bound by EBS, Italy

Reproduction by Ateliers du Regard, Paris

10 9 8 7 6 5 4 3 2 1

www.anovabooks.com

AUDREY HEPBURN

A Life in Pictures Edited by Yann-Brice Dherbier

Foreword

One of the greatest privileges of my life was meeting Audrey Hepburn in 1953. From this encounter sprang a special and enduring friendship that lasted for over 50 years and continues to this day, kept alive by the correspondence I receive from her many devoted fans and admirers who still love and adore her, and to which I reply, of course. Each time it leaves a warm glow in my heart. Audrey was not just unique, she was exceptional, beautiful, loyal, genuine and talented, with a wonderful smile that lit up her beautiful face. Designing for her was a joy because, like me, she was a perfectionist and we understood each other perfectly. She created her very own style, in which I am proud to have played a part – a style that remains both modern and yet timeless. Audrey was the epitome of elegance, in both body and soul.

Hubert de Givenchy

AUDREY HEPBURN

A Life in Pictures By Axelle Emden

I – A quiet child, with quiet endurance

Audrey Hepburn was born in Brussels at 3 a.m. on 4 May 1929. Christened Audrey Kathleen Ruston, she was the only child of her mother's second marriage, an unhappy alliance between nobility and bourgeoisie. Her mother, Ella van Heemstra, was born in 1900 to an influential aristocratic family in the Dutch town of Arnhem. At the age of twenty, she married a former queen's equerry, Hendrik Gustaaf Adolf Quarles van Ufford, with whom she had two sons, Alexander, born in 1920, and Ian, born in 1924; the couple divorced a year after Ian's birth.

Although very religious and proud of her title of 'Baroness', Ella was an unconventional woman. She remarried in 1926; her new husband was Joseph Victor Anthony Hepburn-Ruston, a British man whom she had met some years earlier. Joseph had 'inherited' the name Hepburn through his father, whose first wife, Isabella Hepburn, claimed descent from James Hepburn, third husband of Mary Queen of Scots. Joseph and his three siblings appropriated the maiden name of his father's ex-wife, although in no sense entitled to it.

Joseph and Ella were married in Indonesia and soon returned to Brussels. Joseph claimed to be an international banker but in reality he worked for an Anglo–French credit company specialising in home loans. 'He is often referred to in my mother's many biographies as a banker; yet the sad truth is that he never really hung on to any job. He was a true dilettante and a brilliant one at that: an achieved horseman and glider pilot, he spoke thirteen languages, possessed a humanistic knowledge of many subjects, and had a passion for originality', wrote Audrey's son, Sean Hepburn Ferrer, in his memoirs.

Soon after they married, Joseph took charge of the van Heemstra's property inheritance and the couple quickly began to quarrel about his poor management of the family's finances.

Their daughter, Audrey, was a splendid baby, 'with the most beautiful, merriest eyes you have ever seen', according to the family circle. Six weeks after her birth, Audrey contracted whooping cough and, although she recovered, she carried traces of this illness throughout her life. She was raised by nurses and governesses and always remembered her mother as being cold and distant, although she never doubted her love for her child. 'My mother was extraordinary', she said, 'but she was never affectionate in the sense that I understand that word. For years I looked for affection. She was a fabulous mother … she had a lot of love *within* her, but she was not always able to show it.' As a child, Audrey was rather introverted but very lively, a characteristic she shared with her two half-brothers, Ian and Alexander.

While Audrey Hepburn was always very discreet about her childhood, she later confided that she loved growing up in the van Heemstra environment: 'I had a passion for open-air life', she said, 'for trees, birds and flowers', a passion that remained with her all her life. She was, however, greatly affected by the tensions between her parents, who quarrelled more and more frequently about the family inheritance.

Audrey was five years old when she started school. Her parents decided that she would be educated in England and she was duly sent to boarding school in Kent. She was terrified of being so far from home and disliked communal living and cold showers, although she later described those years as having been 'a good lesson in independence!' Although Audrey was a beautiful child, she began to suffer bouts of bulimia very early on and became a plump little girl with round cheeks. She discovered literature through her mother, who was very cultured, but, more significantly, through her brother, Ian: 'Ian was a real bookworm and when we were small he adored Kipling.' Audrey said. 'I admired him so much that I began to read all Kipling's books just to be like him.' Following in her brother's footsteps, she read all of Edgar Wallace and E. Phillips Oppenheim, although her favourite books were *Heidi* and *The Secret Garden*. At thirteen, she was already amazingly well-read.

Her father, Joseph, had always been drawn to extreme right-wing ideas and he soon became a supporter of Oswald Mosley's fascist movement, as did his wife; Ella wrote several articles for *The Blackshirt*, the party's newspaper. In 1938, Joseph became official director of the European Press Agency, tasked with disseminating Nazi propaganda in England, but by then he was already long separated from Audrey and Ella. In May 1935, his wife had found him in bed with the governess; Joseph left the house and never returned. Audrey was six, and for her it was utterly traumatic: 'A tragedy from which I don't think I've ever recovered', she said as an adult. 'I worshipped him and missed him terribly from the day he disappeared. … I always envied other people's fathers, came home with tears, because they had a daddy.'

Audrey was at school in England until 1939, returning frequently to The Netherlands. She began to suffer migraines, a condition that persisted throughout her life. She also became increasingly anxious and secretive; but then she began to take part in her school's dance classes and discovered a passion for dancing.

At school she was a good student, if rather dreamy, and although she was interested in geography, it was her dancing lessons that brought her out of her shell. When Britain declared war on Germany on 3 September 1939, Ella immediately wanted her daughter back in Holland. Audrey had spent the summer on an English farm, and it was her father, whom she hadn't seen for several years, who came to take her to a private airfield, where she embarked on one of the last planes leaving England. Three days later, Germany invaded Holland. Audrey was now ten and she found it difficult to return to her Dutch roots – the prospect of relearning the language and starting at a new school was not easy for this shy and highly sensitive child.

However, Audrey was soon enrolled in Arnhem's Conservatory of Music and Dance, where she learned the basics of classical ballet in Winja Marova's classes. Her teacher was delighted with her: 'I always enjoyed teaching her', Marova remembered. 'At her first performance, I could see how good she was. When she was on stage, even though she just knew a little bit, you immediately saw that a flame lit the audience.' By this time, Audrey had become a slender girl, tall for her age, with a rosy complexion and brown hair; she made the perfect little ballerina.

Ella received no financial assistance from her husband and, since he had decimated the family fortune, she realized that she needed to work. Accordingly she became an interior decorator, gave bridge lessons and moved into a small Arnhem house with

her children. Although Ella became president of Arnhem's British–Netherlands Society, she was nevertheless very cautious about her British connections. She forbade Audrey to speak English and changed her name to 'Edda', a typically Dutch name, probably chosen for its resemblance to her own. 'During the war, being English in occupied Holland was not an asset; it could have attracted the attention of the occupying German forces and resulted in confinement or even deportation. My grandmother Ella came up with the name "Edda" simply by exchanging the two l's in her own name with two d's. Since most documents were handwritten at the time, Ella may have had one that could easily be doctored ...', explained Sean Hepburn Ferrer.

In Britain, when Chamberlain resigned and Churchill became prime minister, the war took a different turn – in May 1940 Defence Regulation 18B was expanded to include fascist and Nazi sympathizers, and in July Joseph was arrested for 'enemy sympathies' and imprisoned in Brixton. Ella and Audrey were not notified.

II – Wartime suffering and indelible memories

Arnhem is close to the German border; soon soldiers filled the town and 'the noise of artillery became more and more oppressive'. While tension mounted in the little town, a gala was organised on 9 May 1940; ballet star Margot Fonteyn and choreographer Frederick Ashton were touring Holland, Belgium and France with the Sadler's Wells Ballet directed by Ninette de Valois. For young Audrey, it was a magical evening; in her role as president of the British–Netherlands Society, her mother had helped to arrange the performance and the company's visit. For the occasion, she had a long dress made for Audrey, who presented a bouquet of flowers to Ninette de Valois at the end of the performance.

The following day, Holland in turn entered the war. This first day of occupation left its mark on Audrey. 'It was surprising and sinister ... we didn't know quite what had happened. A child is a child is a child and I just went to school.' German became compulsory as a foreign language and, while Nazi censors forbade certain books, the history of Germany became part of the curriculum. Audrey's brothers disappeared: Ian, who had organized student strikes, was sent to a labour camp in Germany, while Alexander, who served in the Dutch Army, went into hiding after the surrender and later joined the Resistance. The baroness buried her jewellery and other valuables in the country and moved with Audrey to a small house at Sickeslaan on the outskirts of Arnhem. Bank accounts were blocked by the occupying authorities and rationing became the norm for the Dutch. In 1942, all the van Heemstra properties were confiscated and their possessions were seized.

Queen Wilhelmina called on her subjects to resist. Ella began to devote her time and energy to the Resistance and called on Alexander and Audrey to help. Audrey's task was to carry coded messages by bicycle. Despite the war, she continued dancing at the Conservatory and took part in concerts and ballets organised by her mother. In July 1941, a critic attended one of these performances: 'As they are all at the beginning of their careers as dancers', he said, 'we prefer to name only one, Audrey Hepburn. Although aged only 12, she stood out by her personality and her highly personal interpretation. She danced the Serenade by Moszkowski to her own choreography.' The same critic praised Audrey again in 1942 and 1943. However, dancing and concerts were not part of everyday life – at home, Ella heated only one room and in the outside world Audrey saw the horror of the deportation. Holland had 130,000 Jews; 30,000 went into hiding.

In February 1941, a Jewish youth movement rebelled against the wearing of the yellow star; the protest was brutally suppressed in Amsterdam and the policy of extermination began. 'I saw whole families with children and babies thrown into cattle wagons, trains with big wooden wagons and just a tiny opening on the roof ... all the nightmares that have haunted me since are due to those scenes,' Audrey revealed years later. Ella's brother was one of the victims of war, shot for sabotage; his young niece was terribly affected. Ella took refuge with her daughter in Velp, in old Baron van Heemstra's villa. Audrey's daily life parallels that of Anne Frank: 'We were both ten when the war began and fifteen when it ended. I read her diary in 1946, and I was so overwhelmed, so moved. It was like reading my life. I have never been the same since reading it.' During those years, Audrey suffered from malnutrition and was so frail she could no longer dance.

One day, as she returned to her home after delivering a message, she was stopped and questioned by a German officer. At that time, the police arrested women and forced them to work in hospitals and military camps; they were picked up at random and sent to various destinations. Audrey stood her ground. She saw that women were being taken away by armed soldiers, but she kept calm. After searching her, her interrogator brought a tobacco pouch out of his pocket and rolled a cigarette while his colleagues continued their arrests; within a few seconds, the young teenager had fled. And now began the most traumatic period of her war – she raced through the alleyways and found a damp, dark cellar in which to take refuge. A tiny opening let in a little air, and Audrey thought she just might be able to pull through with the help of the crust of hard bread and bottle of apple juice she had with her. She collapsed and fell asleep. When she woke she had no idea how long she had slept. She rationed her bread and juice carefully, knowing she might need them for a long time. Although a ray of light broke through occasionally, she soon lost all sense of time. When tanks rumbled and Nazi vehicles shook the cellar's foundations, she froze, rooted to the spot, terrified of being recaptured. This reaction was to have a long-term effect: she developed a permanent ache and her health was shattered. When she could not even remember how long she had lived in that cellar or when she had eaten her last morsel of bread, she decided to break out, since the Wehrmacht and the parachutists of Montgomery were devastating the village and she feared her refuge might be bombed. She fled into the night, passing German armoured vehicles guarding the deserted streets. When she arrived home, her mother – who had imagined the worst – emotionally embraced her daughter before calling a doctor. Audrey had contracted jaundice; she had been nearly a month in hiding without food. Her metabolism had suffered a huge shock, traces of which remained with her throughout her life. 'I was in very poor health. ... By the end of the war I was very anaemic and asthmatic. I had all the illnesses that come with under-nourishment. I also had bad oedema, caused by malnutrition. It brought on swelling of the limbs. All this was due to lack of vitamins. ... In winter there was nothing; in the spring we picked anything we could in the countryside.' In winter 1943, there was severe famine in Holland and 20,000 people died.

The following summer, the Allies liberated parts of Belgium and France, and it was thought that the war would be over by the end of 1944. When Liberation at last came on 5 May 1945, Audrey was sixteen. She danced in the streets to welcome the Allied troops. 'I stood there, just looking at them', she recalled. 'The joy of hearing English spoken, the incredible relief of being *free*, it was something very deep. Freedom was something you could smell. Freedom was the smell of an English cigarette.' With the Liberation, the young Audrey discovered UNRA (United Nations Relief and Rehabilitation Administration), the forerunner of UNICEF. Parcels of food and clothing miraculously arrived and the young girl marvelled at it. She never forgot the joy she experienced, and shared with other children, at opening those packages that fell from the sky.

Her brother Ian returned from Germany and Alexander could come out of hiding at last. 'We had lost everything, of course – our houses, our possessions, our money. But we didn't give a hoot. We got through with our lives, which was all that mattered.'

Audrey emerged from the war years with deep physical and psychological scars that marked her to the end of her days. All her life she was haunted by nightmares, while malnutrition had permanently damaged her metabolism. She never forgot the Nazi horror, the fear and the privation, while she remained convinced of the value of humanitarian aid. 'War left me with a deep knowledge of human suffering and I hope that other young people will never know it. The things I saw during the Occupation made me very realistic about life and I have remained so ever since.' She would say 'Don't discount all the Nazis atrocities that you hear or read about. It was worse than anything you can imagine. I came out of the war grateful to be alive and certain that human relations are the most important thing, much more than wealth, food, luxury, a career and every other thing you can mention.'

III - From Amsterdam to London: from freedom to flight

Following the Liberation, Audrey became a volunteer carer in a nursing-home for Dutch soldiers. Although this work brought her enormous satisfaction in the aftermath of the war, she knew that her vocation lay elsewhere. She wanted to dance, and got a scholarship to the Rambert School of Ballet, part of the celebrated company run by Marie Rambert, who had worked with Nijinsky and gave her name to what is now the oldest English ballet company.

But Audrey had to give up her trip to England because there was not enough money – apart from a few jewels, Ella had nothing more to sell. Leaving behind the evil memories of the war, the baroness decided to leave Arnhem for Amsterdam, where she set up home with her children. The family lived in the cellar of a well-to-do household, for whom Ella worked as cook and governess. Despite her poverty, she managed to continue to support Audrey's ballet studies; both women were convinced that Audrey's future was as a dancer. For three years, she took classes with Olga Tarassova, a very strict Russian ballet teacher who taught her the 'European style'. Music was the only relaxation that Audrey allowed herself and she went to concerts regularly. She was eighteen when Dutch director Charles Huguenot Van der Linden sat in on one of Tarassova's lessons with his associate, producer

H.M. Josephson. They were looking for a young woman to play the part of an air hostess in a low-budget travel film about Holland. 'It has to be the tall, thin girl with the *eyes*', concluded Van der Linden, and his associate and Tarassova agreed. So Audrey worked for three days in her small part in *Nederlands in 7 lessen* (Dutch in 7 Lessons). She and her mother were thrilled.

A year later, Ian and Alexander left on an adventure trip to India, and Audrey managed to persuade Ella to accept the Rambert School scholarship. The two women set out for England with £35 in their pocket. 'I was spurred on by our difficulties', Audrey confided. 'In retrospect, I am happy that things were so hard. Otherwise I would not have dared to go forward. I have always been more introverted than extroverted, but when necessary I can break out of myself to keep up appearances. I was very optimistic about my chances because the opposite would be too depressing. In reality, I didn't really know what I was getting into when I persuaded mother to leave for London.'

They arrived in London at the end of 1948 and installed themselves in a hotel in the King's Cross area. Ella worked as a florist, then as a cook, beautician and saleswoman before becoming manageress of a Mayfair apartment block, where a cheap flat came with the job. Audrey was nineteen when she began studying with Marie Rambert. She worked from 10 a.m. until 6 p.m. but, despite her motivation, the result was disappointing. 'My technique didn't compare with that of the girls who had had five years of Sadler's Wells teaching', she said later. She was also disadvantaged by her physique; being taller than the others, her height made it impossible for her to blend into the corps de ballet. Rambert did not discourage her, but Audrey quickly came to the 'right conclusion', although she continued with the classes for a while, so as not to disappoint Ella; since the two women had come to London for the Rambert School, they could not abandon it so quickly. As a pupil of the school, Audrey was able to attend rehearsals of productions in the Mercury Theatre; she was fascinated by the world of the stage and drawn to the theatrical atmosphere. She then embarked on a modelling career in order to finance herself without the help of her mother, to whom she was very close during those years in London.

Next Audrey became a chorus-girl in *High Button Shoes*, a musical comedy by Jule Styne. She knew absolutely nothing about musical comedy; she had never learned modern jazz and her audition seemed to her so disastrous that she went home in tears, certain she had made a fool of herself. It's true that Audrey was not hired for her talents. 'She's no good as a dancer but she's got lots of verve', noted the co-producer Jack Hylton about her audition. It was her personality and her grace that charmed the selectors – she was hired.

In December 1948, Audrey embarked on a performance that she would continue for nearly 300 nights, dancing Jerome Robbins' choreography to the music of Jule Styne. She had been performing for several weeks when impresario Cecil Landeau visited the production; he was 'captivated by a girl who crossed the set. It's difficult to explain. It wasn't any big deal: just two huge dark eyes and a fringe floating through the scene.' For Nickolas Dana, one of the dancers, 'Audrey was the prettiest girl in the show. ... She had one skirt, one blouse, one pair of shoes and a beret, but she had fourteen scarves. What she did with them week by week you wouldn't believe. ... She had the gift, the flair of how to dress.' Among the cast, Audrey

revealed her talent for clowning and made friends with Kay Kendall, another chorus-girl, who would go on to marry Rex Harrison. She continued modelling for magazines and took acting lessons with Felix Aylmer, all the while continuing to practise her barre exercises. But, at twenty, she faced facts: 'I had discovered that my height was a serious obstacle to a career as a dancer. I would have had to work myself to exhaustion for many years before achieving limited success. But I couldn't afford to wait years; I needed money too much.'

In May 1949, Audrey left the Rambert School; she also refused to go on tour with the cast of *High Button Shoes*. Cecil Landeau had offered her a part in *Sauce Tartare*, which she accepted even before knowing what she had to do. The revue's casting was extraordinary: it included black American singer Muriel Smith, the star of Broadway's *Carmen Jones*, plus artists from around the world, from Norway to South Africa, Russia to Spain. The production was an instant hit, but Audrey was so exhausted she found it hard to enjoy it. She worked relentlessly and slept throughout the day during her days off. Anthony Beauchamp, a fashionable photographer who had photographed Vivien Leigh and Greta Garbo, singled Audrey out from the earliest performances. He was charmed by her: 'I couldn't believe she was real', he said later. 'That face was such a web of contradictions! Mystery and purity, profundity and youthfulness, immobility and vivacity. ... I had the feeling of making a true discovery when I found her. She had such freshness and a kind of spiritual beauty.' When his photographs appeared in *Vogue*, many magazines clamoured to put this face on their covers and Audrey Hepburn started to become familiar to British women.

Next she embarked on *Sauce Piquante* with the same producer and, although she could not dance as well as her colleagues, she enchanted her public. 'Even if she jumped up and down, the audience would still be attracted to her', recalled one the show's performers, Bob Monkhouse. 'What Audrey had in *Sauce Piquante*, and what has sustained her through [her] career, was an enormous, exaggerated feeling of "I'm helpless – I need you". When people sense this, they respond to it immediately, perhaps not realising why they're doing so. ... She seemed to be too pretty, too unaware of the danger. It was quite extraordinary. [That] impish grin seemed to go from one earhole to the other. She looked incredibly radiant because, at that time, it was uncontrolled. The lips actually turned inside-out and the eyes went sort of potty, like a Walt Disney character. It was so lovely, one stepped back a pace.' As well as photo sessions, Audrey appeared on television occasionally. Her beauty contrasted with that of the stars of the period; in the 1950s, women who were considered great beauties did not have the allure of a boyish young girl. But Audrey had an extraordinary magnetism. Natural and frank, she was appreciated by her colleagues, as much thanks to her good education as to her sunny and hard-working temperament.

Audrey, whom wartime had cheated of teenage romances, began dating one of the actors in the cast, a Frenchman called Marcel Le Bon. He was the first man to give her so much attention, to shower her with bouquets of flowers and poems, and to take her out. She was charmed by his attitude, but their little romance caused trouble in their professional life. Cecil Landeau, who habitually distrusted the love affairs of his cast members, introduced a no-marriage clause in Audrey's contract. Following her heart, she moonlighted with her beloved in a cabaret number at a night-club, refusing an offer from ABPC, who had persuaded the director Mario Zampi to engage her for a film. 'I knew very little about the cinema, at least not enough to realise that I had turned down an interesting opportunity', Audrey said later. 'At this period, opportunities came thick and fast, one after another, and I barely sorted them out. ... Our engagements fell through and I was faced with the reality: people lied! It was a big shock. It affected Marcel's mood and he took his disappointment out on me. We began to quarrel; he packed his bags and left for the United States.'

Audrey went back to Mario Zampi, trying to reclaim the major role he had offered her, but it was too late. However, the small part of a cigarette vendor still remained; she took it and was offered a seven-year contract with ABPC studios. *Laughter in Paradise* was released in 1951. She next appeared in *One Wild Oat*, followed by *Young Wives' Tale*. Although her acting was unremarkable, she came across very well on screen. In September 1950, she had another minor role in *The Lavender Hill Mob*, where she came to the attention of Alec Guinness: 'She had only half a line to say, and I didn't think her delivery was anything special', he said. 'But her faunlike beauty and presence were remarkable.' Guinness, who had never before recommended anyone, advised the director Mervyn LeRoy to test Audrey.

Nothing came of the test, but shortly afterwards Audrey was hired by Ealing Studios for *The Secret People*, a melodrama directed by Thorold Dickinson. She played the sister of Valentina Cortese, with whom she became great friends. In the role of a dancer implicated in a political conspiracy following the death of her father, she played her first real character. Shooting started in early 1951; the rehearsals were difficult and Audrey suffered from the cold throughout filming, but she hung on. Making this film taught her how to draw on real-life emotions in order to make her character weep. She found the director's advice considerably more helpful than anything she had learned in drama school and she was delighted with the experience, which enhanced her professional reputation.

Audrey was now living a carefree, fun-loving existence. James Hanson, the son of a rich businessman, came into her life. The young and naïve Audrey quickly fell for this twenty-nine-year-old womanizer, who loved sports cars and nightclubs. Her mother worried about the relationship as soon as the young lovers began to talk of getting engaged. James was an excellent match, but he was unlikely to be a faithful husband. Audrey was in love, but she did not hesitate to leave her 'Jimmy' several times. ABPC suggested that she go to Monte Carlo, where the studios needed a bilingual actress for a film. 'I took the part for my usual reasons', Audrey explained. 'I was to play a movie star and the costumes were fabulous. There was a Dior dress that I was told I could keep – reason number one. Secondly, the film was to be made on the Côte d'Azur. The third reason was that filming of the movie I really wanted to make had been postponed just long enough to allow me to do this one too.'

IV – From Monte Carlo to Los Angeles, before *Gigi* became *Sabrina*

As Audrey was preparing to leave for Monaco, she attended a private dinner at the Hotel Ambassadeurs, where she met Radie Harris, an American journalist who quickly became one of her closest friends. Humphrey Bogart, John Huston, Sam

Spiegel and Lauren Bacall were also present, as well as Faye Emerson, a star of the earliest days of US TV.

It was *Monte Carlo Baby* that launched Audrey; the film was directed by Jean Boyer in two versions, the French one being called *Nous irons à Monte Carlo*. Her part in the film lasted about twelve minutes, but it led to her meeting with the famous French writer Colette, who spotted her at the Hôtel de Paris and was immediately intrigued. For two years, Colette had been looking for a young woman capable of playing Gigi, a spirited child-woman. Anita Loos, the American author of *Gentlemen Prefer Blondes*, had adapted *Gigi* for Broadway, but the film company had searched Europe for a young woman who would fit the character. When Colette saw Audrey, she knew she had found Gigi. Audrey could hardly believe her ears and replied timidly that she was not experienced enough for the role, but the writer, and Audrey's mother, quickly persuaded her otherwise. Colette convinced Anita Loos and producer Gilbert Miller to hire her; the London press seized on this future New York star and several of Audrey's films were reissued.

The director Frank Capra had bought the rights to *Roman Holiday* during the 1940s. His company, Liberty Films, was sold to Paramount in 1948 and negotiations with Elizabeth Taylor and Cary Grant were under way. But Capra abandoned the project because the budget Paramount gave him was too small. Director William Wyler agreed to do the film, on condition that he could shoot it on location in Rome. At the same time, Gregory Peck let it be known that he would like to try his hand at comedy and, although Jean Simmons was being considered for the female lead, Wyler insisted he did not want a star for this film. 'I wanted a girl without an American accent to play the princess, someone you could believe was brought up a princess', he said. Audrey was twenty-two when she went to audition for the part in London. She was asked to do a screen test; she wanted Thorold Dickinson to direct it and, by a happy coincidence, Wyler had already contacted him. The test was very successful; Paramount wanted her for the film. Audrey was still under contract with ABPC, but the administrative issues were sorted out and she signed the ideal contract with Paramount – one that also allowed her to act on stage and appear on television.

In September 1951, Audrey embarked for New York. It was the first time she had left Europe, and she travelled alone. She had not been alone since the war years and found the eighteen-day voyage rather unsettling. She had no experience on Broadway, still less in Hollywood, and she was the only actress to have been hired simultaneously for a New York stage production and an American film.

When she landed on 3 October 1951, New York took to her on sight. She installed herself at the Blackstone Hotel and next morning met with the producer of *Gigi*, Gilbert Miller. He got a nasty surprise: he had left a slender, boyish young woman; now he saw an almost-plump Audrey. She had put on fifteen pounds during the voyage. Difficult days followed: the young actress went on a strict diet and her fellow actor Cathleen Nesbitt coached her in her part incessantly. 'During the first days of rehearsal, I couldn't be heard beyond the first row. I worked day and night. ... At last, I could be heard.' Audrey had heroic energy, but her acting was still patchy and awkward. When her boyfriend James Hanson joined her, she embarked on a round of nightlife with disastrous consequences for her work. Jimmy's parents owned nightclubs in New York and the couple spent their nights at El Morocco until *Gigi*'s director, Raymond Rouleau, came down heavily on Audrey. From that point on, Audrey Hepburn became the irreproachable professional that she remained for the rest of her career – she followed her diet to the letter and went to bed early, avoiding sophisticated parties. Her morale, which had sunk to its lowest, gradually increased. She had several photo sessions with Richard Avedon and Irving Penn for the show's posters. The brilliant Avedon gave her some advice which she would put into practice throughout her life: to preserve the originality and the purity of her features. *Gigi* previewed in Philadelphia; reviews were good without being ecstatic, but the Broadway opening night in November 1951 was a public triumph. Audrey's performance was hailed by the *New York Times* and the *Herald Tribune*, and the play sold out the following day. Her celebrity status pleased Audrey, but she retained her freshness and modesty.

One month later, her engagement to James was announced in the press. The source of this official announcement remains unknown, but as far as Audrey was concerned, marriage could wait. The photo of James had disappeared from her dressing-room and she was fully occupied with her professional life and her dancing classes.

Gigi ended in May 1952 after more than 200 performances. Audrey had no time to rest; she had to fly to Rome to start work on *Roman Holiday*. On her arrival in Italy, she immediately met Gregory Peck, then aged thirty-five and a big star since 1945. He was very attentive to the young actress during filming, which was done under difficult conditions. The Roman summer of 1952 was one of the hottest of the century, so much so that the director restricted himself to very few takes. During shooting, Audrey became friendly with Connie Wald, wife of Jerry Wald, one of Hollywood's most creative and prolific producers. She stayed in touch with Connie, who became her best friend.

Roman Holiday was released in 1953 and Audrey Hepburn would become an iconic figure during the 1950s. A byword for grace and elegance, her physique also set a new standard of beauty – huge eyes, thick lashes, a fringe and an imperceptible bust became the fashion. Audrey was a departure from the voluptuous appeal of Marilyn Monroe and Jayne Mansfield, and she soon launched a vogue for Salvatore Ferragamo flat ballet slippers.

Rumours about a liaison between Gregory Peck and Audrey died down when her marriage to James was announced for the end of 1952. She was still in no hurry, and began the road tour of *Gigi* in America. Paramount planned her next project to be an adaptation of a play by Samuel Taylor, *Sabrina Fair*. A satire on American high society, *Sabrina* attracted Audrey because of its quality of a modern fairytale; it was she who read the script and suggested that the studio should acquire film rights to the work. The studio did so and cast Humphrey Bogart to play opposite her, directed by Billy Wilder.

Until now, Edith Head had designed Audrey's costumes; she also worked on the *Sabrina* wardrobe, but the heroine was dressed by a Parisian couturier for the French scenes. Audrey had suggested that the costumes should be designed by Hubert de Givenchy, who had just left Schiaparelli to open his own couture house.

They met for the first time in 1952, in Paris's 18th arrondissement. 'One day someone told me that "Miss Hepburn" was coming to Paris to select some clothes', recalled Givenchy. … 'I only knew of Katharine Hepburn. When I saw this petite young woman with huge eyes, I was at first surprised … almost disappointed! At the time, Audrey was not yet well-known in Paris. She wanted to try on my dresses. I held back, but she knew how to be very persuasive. "Let me try one", she said to me. It fitted her exactly, like Cinderella's glass slipper! Afterwards, everything happened very fast. … My magic was hers. She brought to the clothes her own innate grace. At the time, I also dressed Elizabeth Taylor and several other Hollywood stars, but no relationship lasted as long as that with Audrey. She was a very loyal woman. Working with her became a pleasure. We amused ourselves, we danced! There was something extraordinary between us, a permanent complicity. We would telephone each other three or four times a week. In one sense, yes, she was my muse. Audrey was not a spoiled child. She knew she had talent, but she was not spoiled by her success. For me, she was a doe-eyed angel.' A great friendship was born when filming began. Givenchy named one of his fabrics *Sabrina* and Audrey inspired him to create a scent, *L'Interdit*, which was launched six years later. 'If Hubert de Givenchy was the arbiter of masculine elegance, he was also the archetype of what a man should be', wrote Sean Hepburn Ferrer, Audrey's son. 'To be a gentleman means, as the word says, that you must first be a gentle man,' my mother taught us. And that he was. Together they created the Audrey Hepburn look, the externalization of her style. … As a result of their collaboration, she has often been referred to as the most elegant, the most stylish, woman in the world. But that elegance had its roots in both their inner values. It came from the right place. It wasn't a way to be noticed but a way to be humble.'

Sabrina is a straightforward product of the Hollywood machine. The atmosphere during filming was strained; work was done with speed, precision and conformism. The actors did not mix with the technicians, or with the producers, and everyone was under pressure from the columnists; at that time, Louella Parsons and Hedda Hopper were the rainmakers in Hollywood. The fascist past of Audrey's father came vaguely to the surface at this point, but provoked no reaction. The actress was paired with two box-office stars, William Holden and Humphrey Bogart. Bogart had been second choice after Cary Grant, which he took very badly. He did not have the reputation of being an easy actor; his difficult character and his liking for a drink were well known. Audrey, who had admired him very much in *Casablanca*, bore the brunt of his tantrums; she did not respond to his tyrannical behaviour and Billy Wilder kept him within bounds. During this tense filming, Audrey was captivated by a new passion – she fell in love with William Holden. However, when he told her that, although he was ready to leave his wife, he wanted no more children, she left him immediately. Much later, he confided that Audrey had been 'the love of his life', a love for which he consoled himself several months later in the arms of Grace Kelly.

During filming, the press went wild about Audrey. In September 1953, *Roman Holiday* was released and the reviews were ecstatic. The actress made the cover of *Time* magazine, while public and critics lauded her charm, her beauty, her carriage and her elegance. In Europe as in America, enthusiasm was enormous, although the British press was more reserved. Audrey moved to Los Angeles, taking a small apartment not far from Westwood Village. *Life* devoted a six-page profile to the independence of this woman who 'escapes all definition'. This 'abandoned' child

and 'woman of the world' was photographed in her solitude or on her bicycle. Although Audrey was now known on both sides of the Atlantic, her price remained well below that of the stars of the time: she was paid $15,000 dollars for *Sabrina*, little more than she received for *Roman Holiday*, but for her 'what mattered was not the money but being a good actress'.

When filming on *Sabrina* ended, she led a quiet life that contrasted with that of other inhabitants of Beverly Hills. She went cycling in casual clothes, smoked very strong cigarettes – in moderation – and spent her weekends alone in her little apartment. Her fame grew, but she did not lose her modesty; although her face dominated the magazines, she continued to find it too large and thought her physique was ordinary. As for her talent, no one was harder on her than herself. She tried to learn comedy but for the moment, in her own eyes at least, she didn't really know how to act. She was still full of anxieties, and although she was determined to succeed, she was never free of doubt.

V – Mrs Mel Ferrer: A funny little face between war and peace

In summer 1953, Audrey was in Paris, where she went to see *Lili* at the cinema and was so fascinated that she returned twice. The heroine, Leslie Caron, bore a strong likeness to her, but it was Caron's screen partner, Mel Ferrer, who made the biggest impression on Audrey. Mel Ferrer had a lot of drive and obvious class but, despite his charm, he was not yet a star. The 35-year-old actor was also a cinema and theatre director and had written children's stories. He knew everyone in Hollywood and on Broadway and, as well as being charming, he was cultured. Like Audrey, he spoke several languages and had come through difficult times – he had contracted polio and now fenced to strengthen a half-paralysed arm. He was a very hard worker, with overflowing energy, and never stopped. The only problem was his history of three marriages, with a third separation to come. Audrey met him in London the same summer, thanks to Gregory Peck. Mel was there for the première of *Lili* and to play King Arthur in *The Knights of the Round Table*. Audrey told him how much she wanted to work with him and soon after he suggested a Giraudoux play, *Ondine*.

At the end of 1953, he came to Los Angeles and their romance rapidly took a passionate turn. They rehearsed the cast of *Ondine*, which was to be staged in Boston and then on Broadway. Audrey moved to New York, where she rented an apartment in Greenwich Village; Mel moved in with her.

The couple tantalised the press, while Audrey's performance in *Sabrina*, released at the same time, was universally praised. Preparation for *Ondine* made Audrey increasingly anxious, and nothing was ready when Ella disembarked in New York. The actress was in a deep depression and on Broadway a doctor waited in the wings every night. Everyone considered that Mel was responsible for Audrey's state; his jealousy and possessiveness kept her from her friends. The critics were full of praise for Audrey but much harder on Mel.

In March 1954, Audrey received an Oscar for her performance in *Roman Holiday*. Wearing a white Givenchy dress, she accepted the award at the NBC Century Theater, to which she had rushed after a performance of *Ondine*. She also won a

Tony award for best stage actress in *Ondine*. 'How will I ever live up to them?' she said. 'It's like being given something when you're a child – something too big for you that you must grow into. ... Acting doesn't come easy to me. I put a tremendous amount of effort into every morsel that comes out.'

Audrey worked hard and although she was thrilled with her Oscar, she was exhausted. She had played in every performance of *Ondine*, and in May her doctor ordered her to quit. Things were difficult with Mel and her health, like her morale, was poor. Her asthma returned and she was pale and very thin. She went to Gstaad in Switzerland to rest, then Mel found her a mountain retreat in Bürgenstock and made sure that the owner, Fritz Frey, watched over her. A healthy regime was prescribed and she was told to eat regularly. It worked; her tension relaxed and her asthma disappeared. Feeling better, she accepted Mel's marriage proposal, made before they parted, and sent him a platinum watch engraved with 'Mad about the boy', the title of a Noel Coward song.

They were married in a civil ceremony on 24 September 1954. Although the couple tried hard to keep their wedding private, a photographer managed to infiltrate the mayor's office. The following day, police mounted guard outside Bürgenstock's Protestant church, where a religious ceremony was held in the presence of Audrey and Mel's twenty-five guests. Immediately after the wedding breakfast, the couple took leave of their guests and retired to Audrey's chalet for the weekend before departing for Italy, where they stayed for a month while Mel completed filming *La Madre.* For Audrey, marriage was everything: 'If we hadn't needed my income, I would have given up the cinema the very day of my marriage', she said.

It didn't take the press long to dub Mel 'Mr Hepburn', which created some friction between the young couple. Audrey's husband never had her aura or her celebrity, and not everyone liked him. Throughout their life together, this disparity would cause tension.

After her marriage, Audrey remained in love, but her happiness was always overshadowed by her anxieties and her psychological and physical fragility. She was very candid about her fears and anxieties. In 1950, she talked easily and with much insight about her feeling of insecurity. 'It comes from the fact that my father left us. All my personal relationships have been marked by that feeling of abandonment that has never left me. When I fell in love and got married, I lived in permanent fear of being abandoned.' She was never free of anxiety.

Mel and Audrey wanted to adapt *Ondine* for the cinema, without success. They next agreed to star in Dino de Laurentiis's adaptation of Tolstoy's *War and Peace*, but while Audrey was preparing to play Natasha opposite her husband's Prince Andrei she became pregnant. 'For me, nothing is more important than having children', she said. She was ready to give up the part, but the producer delayed filming until the end of summer 1955. Audrey was radiant: soon she would be a mother and she was being acclaimed for her performance in *Sabrina*.

She was in London, where they had rented an apartment while Mel was filming *Oh Rosalinda!,* when she was nominated for an Oscar in the best actress category for *Sabrina*; the *New York Times* and the *Chicago Tribune* ran rave reviews, as did

Time, which noted simply: 'Not acting, just being. It's the rarest of talents and Audrey has it.' Audrey's personality, her physique, her simplicity and her acting were unanimously hailed. Hundreds of young girls adopted the 'Hepburn cut', yet Audrey was astonished to be recognised in the street. Cecil Beaton remarked in *Vogue* that 'nobody ever looked like her before World War II ... now thousands of imitations have appeared. The woods are full of emaciated young ladies with rat-nibbled hair and moon-pale faces.' It was a craze Audrey couldn't understand.

In the winter of 1955, she had a miscarriage and returned to Switzerland, devastated. 'For the first time I was close to a breakdown', she confided. She fought against depression through faith and work, but nothing helped. 'I wanted to cancel the film, cancel my life', she said. Her husband advised her to fling herself into work and, although she remained inconsolable, *War and Peace* helped her get through this terrible time and the couple grew close again. However, Natasha was the toughest role the actress had ever played; the film was made in the Cinecittà studios in the heat of August and shooting was difficult. Audrey insisted that Hubert de Givenchy should approve every one of her costumes and that Alberto and Grazia de Rossi should do her hair and make-up. The couple remained with her throughout her career.

At this point, George Stevens offered Audrey the role of Anne Frank, but she refused. Anne Frank's life was too close to her own. Then producer Hal B. Wallis offered her the lead in *Summer and Smoke*, adapted from Tennessee Williams' play, while William Wyler wanted her to star in *L'Aiglon*, a play by Edmond Rostand for which he had acquired the rights. She was deluged with script offers, but what mattered to her most, after two years of marriage, was being with her husband. She agreed to make *Funny Face*, a Paramount musical starring Fred Astaire, on condition that it was filmed in Paris, where Mel was working in *Elena and her men*, directed by Jean Renoir.

Funny Face was based on a musical, *Wedding Bells*, about a bookseller who is discovered by a New York fashion photographer. Audrey was thrilled; she said it was 'the dream of her life' to work with Fred Astaire, but she was also terrified at the possibility of not being up to it. Her co-star was considered one of the century's best dancers, and as well as dancing she had to sing. Ironically, however, it was Audrey who was the star: 'She absolutely insisted on having me as her partner', said Fred Astaire in a book published in 1971. 'Otherwise, I would never have got the part. They just wouldn't have hired me, you see ... I couldn't have got them to do the movie. She was the star and she said "Right, I'll do it if you get Fred Astaire." That's the finest compliment you could possibly get.'

Filming took place in Paris in April 1956. Mel and Audrey stayed at the Hotel Raphaël. Fred Astaire was wonderful with Audrey; he was attentive and reassuring, later saying that he had adored working with her. The actress worked hard and filming went well. It was the same on the set of her next film, *Love in the Afternoon*, which started two weeks after her collaboration with Fred Astaire.

Ariane is a musician who falls in love with a playboy who is being investigated by her father, a detective. The playboy is none other than Gary Cooper, who soon falls for her. Audrey was then twenty-seven, Cooper was fifty-five. Gary Cooper, like Henry

Fonda and Fred Astaire, was a real Hollywood star. John Wayne called him 'the world's best man', while for Lauren Bacall, he was the most beautiful man in the world. Like most of her co-stars, Cooper fell under Audrey's spell. 'I've been in the movies more than fifty years', he said, 'but I've never had a co-star as fascinating as Audrey. She puts more life and energy into the business of acting than anyone else I've ever met.' Maurice Chevalier, who played her father, was equally smitten. It was a happy picture, thanks to the harmony between the three; but at that time Audrey worried a lot about her looks. She insisted on seeing and approving all publicity photographs and often demanded retakes, which Billy Wilder refused, giving her reassurance instead.

Love in the Afternoon was received with reservations, and when shooting finished Audrey found herself alone in Paris. Mel was filming in the south of France and the couple met only at the weekends in Saint-Tropez. But solitude always helped Audrey to regroup. She granted few interviews, giving journalists and the public the impression that she was inaccessible; when she did, however, she was always very playful with reporters and generous with her time.

Next, the actress turned down the adaptation of Françoise Sagan's novel, *A Certain Smile*, as well as a non-musical biography of Maria von Trapp, whose life story would become *The Sound of Music*, starring Julie Andrews. In 1957, she worked with her husband on *Mayerling*, but there was little on-screen passion between the couple. *Mayerling* was one of the most expensive television productions ever filmed in the US but, despite the ambitions of the producer, Anatole Litvak, it was a flop.

The same year, *Picturegoer Film Annual* voted Audrey 'Actress of the Year'; she looked sensational in a feature by the photographer Anthony Beauchamp. She flew to Mexico, where her husband was working on *The Sun Also Rises*, and then to New York before returning to the chalet in Bürgenstock, where she spent the rest of the year. The end of 1957 was difficult – *Mayerling* was a fiasco, *War and Peace* had a low-key reception and the Hepburn–Ferrer partnership was floundering. Then she agreed to a proposition from Warner Brothers, who sent her *The Nun's Story*. Filming would separate her from her husband for a time.

During the years she spent with Mel Ferrer, Audrey saw her father again – Mel tracked him down through the Red Cross. He was living in Ireland. 'When my grandfather answered [the phone]', wrote Sean Hepburn Ferrer years later, 'he immediately knew who my father was. He had been following his daughter's life and career from afar through the newspapers. He listened carefully as my father explained that he thought that a meeting between them might resolve, for both him and my mother, the void that this long separation had created. Joseph responded that he would be very happy to see Audrey again and they agreed on a date and a place: the Shelbourne Hotel in Dublin … my mother and father went downstairs and there he was, standing in the lobby, looking much older yet elegant in his somewhat tattered tweeds. It took my mother only a fraction of a second to understand. The man was frozen. He couldn't take a step, or lift an arm, let alone hug her … he was totally disconnected …. The man she had longed for her entire childhood was in reality an emotional invalid. And so my mother did it: she stepped forward and hugged him, knowing full well that was going to be it. She chose to forgive him, instinctively, in one instant. She chose to take away the inhibitions that had to do

with his regrets toward her. There were no tears of joy at the reunion – knowing full well that those would have made him uncomfortable, she held them all in. The rest of the day – the lunch, the afternoon – consisted of polite pleasantries. My father used the pretext of visiting some antique shops to let them have some time together. When my father returned, he found my mother waiting in the lobby. They were done, and my grandfather had left. All she said was, "We can go home now." There was nothing left to say or do. During the flight home, she thanked my father, saying that this trip had somehow resolved the issue for her. And she didn't need to see her father again, she added. He mother had spent the war spewing poison about him, about his disappearance, about his lack of support of any type. She had to see for herself; and when she did, indeed there was nothing there.' Deeply disappointed, Audrey hardly ever saw her father again, although she sent him money for the rest of his life.

VI – The essential *Fair lady*: Sean and 'La Paisible'

Audrey recovered her spirituality and some of her fighting spirit in *The Nun's Story*. She played a nursing sister working in the Belgian Congo, who renounces her vows following the death of her father, killed by the Nazis. 'I was attracted to that subject more than I had ever been by any other', she remembered. In preparation for her role, Fred Zinnemann took Audrey to meet Marie-Louise Habets, the nun who had inspired the book by Kathryn C. Hulme from which the film was scripted. Studio filming started in Rome, then the crew flew to the Congo in January 1958. Audrey was overflowing with energy, and even when shooting was over she seemed to remain in character. The reviews were glowing and the film was nominated for eight Oscars. Audrey lost out to Simone Signoret, nominated for *Room at the Top*, but the whole team rejoiced at the success of the production. Audrey's next project was *Green Mansions*, directed by Mel, which got good reviews but was a box-office flop. The couple's professional collaboration came to an end with this film.

Audrey's next movie was *The Unforgiven*, and she flew to Mexico to film with Burt Lancaster and director John Huston. Relations between the two men were tense, but nothing could dampen Audrey's enthusiasm; she loved Ben Maddox's screenplay and was getting paid $200,000. But the real reason for her happiness was that she was once again pregnant.

In January 1959, while riding bareback on a white stallion, she fell off onto her back. She had four fractured vertebrae and a badly sprained foot but the baby was safe. Audrey was very weak, filming stopped and she left for Los Angeles. Three weeks later she was back on her feet, and in April the film was finished. Her courage and resilience impressed the whole crew, who were amazed at the willpower and strength of such a frail creature. Returning to Switzerland, however, she was to face another, much worse, disaster: for the second time, she lost a baby. Audrey weighed less than 45 kilos (100 lbs), smoked three packets of cigarettes a day and struggled against depression. Mel was solicitous and gently helped her over it.

In spring 1959, she was offered the role of Cleopatra, but Paramount refused to release her and it was Elizabeth Taylor who starred in the most expensive film made to that date. Still in low spirits, Audrey refused *West Side Story* and Otto

Preminger's *The Cardinal*. Seven months after her miscarriage, she again became pregnant and followed her doctor's advice not to accept any work. She accompanied Mel to Rome, where he was filming *Blood and Roses*, directed by Roger Vadim.

On 17 July 1960, Audrey gave birth to a son. As soon as Sean was born, he became the centre of her universe. 'Like all new mothers, I couldn't believe, at first, that he was really for me and that I could keep him', she told a reporter from *Look*. 'I'm still filled with the wonder of his being, to be able to go out and come back and find that he's still there.' Although she was blissfully happy, she remained anxious; she was afraid her son would be kidnapped and was always subject to violent attacks of nerves.

Screenplays showered down, but Audrey refused all offers until, six months after Sean's birth, she fell in love with a script, *Breakfast at Tiffany's*, from the novella by Truman Capote. She was thirty-one and thrilled by this part, which marked a real departure in her film career. The character of Holly was sophisticated but a bit 'kooky'; Audrey found her 'irresistible'. 'I thought that I could play this character. A real revolution for me. After so many films, I no longer felt like an amateur actress; I knew I'd always have something to learn but I also discovered that I could give something of myself. I knew this role would be a challenge, but I wanted to tackle it', she said.

She arrived in New York to start filming in October 1960, accompanied by Mel. True to form, she was both nervous and excited; her co-star, George Peppard, had studied at Lee Strasberg's Actors' Studio and, while he was charming to Audrey, his approach to acting was nothing like hers. He would think about his role and analyse it, while Audrey, who had never worked with Method actors, acted instinctively and relied very little on technique. She was unnerved but, as usual, worked tirelessly and gave a brilliant performance. The film, underscored by the music of Henry Mancini, who became a close friend of Audrey's, was a success. 'Utterly improbable but extraordinarily effective', summed up the *New York Times*. Mancini was nominated for an Oscar for the music and although Audrey was also nominated, it was Sophia Loren who won the statuette for *Two Women*. *Film Daily* named Audrey 'Actress of the Year' and in Italy she received the David de Donatello award.

Audrey next accompanied Mel to Paris, to the Alps and Yugoslavia before returning to Beverly Hills, where they rented a handsome house. During these years, Audrey led a quiet, unsophisticated life, devoting herself as much as possible to Sean and, although she sometimes complained about forever packing or unpacking suitcases, she found a good balance between filming and her family life. She turned down several films before accepting *Children's Hour*, a surprising choice: she played a lesbian alongside Shirley MacLaine, a teacher 'whose reputation was destroyed by lies'. Although Audrey was tired and irritable, she got along well with her co-star and their mutual sympathy helped them to forget the film's failure. When filming was finished, Audrey was exhausted, her frailty increased by the death of her beloved Yorkshire terrier, Famous, given to her by Mel.

By 1962, Audrey had been married for seven years. Her heart was set on a single wish – to have another child. Although she tried hard to spend the maximum time with her family, she was often separated from Mel, who was having affairs, as she eventually discovered. The couple always seemed close in public, but cracks had begun to appear. Audrey was tense and, since the filming of *Breakfast at Tiffany's*, she had acquired a stalker, a young man who followed her whether in Europe or the US. When her chalet was burgled in July 1962, her nervousness was at its height – her underwear was stolen, as well as the Oscar she had won for *Roman Holiday*. The lovesick burglar was speedily arrested, but nothing could calm Audrey's fears, the more so since Mel seemed less attentive and left for Spain to film *The Fall of the Roman Empire*. At this point, she decided to accept Richard Quine's offer of the lead in *Paris – When It Sizzles*, although she worried about renewing acquaintance with William Holden, an old flame she had not seen for ten years. She left for France, where the two stars soon sparked journalists' curiosity. Audrey hoped to make her husband jealous; it didn't work. She asked Mel for a divorce and he abandoned a flirtation with the Duchess of Quintanilla to return to his wife.

Paris – When It Sizzles received mainly negative reviews, but the critics, always delighted to see Audrey on screen, were kind to her. Her next film was *Charade*, co-starring with Cary Grant, directed by Stanley Donen. The first meeting between the two stars was not auspicious, but filming went smoothly. 'All I want for Christmas', said Cary Grant when shooting ended, 'is another movie with Audrey Hepburn.' The film was a suspense comedy with a three million dollar budget; reviews were excellent and it was a box-office success.

While Audrey was filming *Breakfast at Tiffany's*, a journalist asked her what part she would like to play next. 'That's easy to answer', she replied, 'I'd do anything to play Eliza Doolittle in *My Fair Lady*.' In October 1962, her wish was granted; she signed a million-dollar contract to star with Rex Harrison. Jack Warner was ecstatic, as he felt he needed an international star to play the heroine of his film; but in Hollywood the climate was frosty. Both the press and people in the film industry reckoned that the part belonged to Julie Andrews, who was outstanding in the musical that had made her famous. Audrey was mortified by the situation but thrilled to be playing the part, especially as George Cukor was to direct. She set up home in a large white house in Bel Air, accompanied by Mel, Sean and Gina, the Italian nanny. Cukor did not get on with Cecil Beaton, the designer and photographer, and filming was difficult.

Beaton immortalised Audrey in a classic photo-sequence taken during shooting. Photographed in the *My Fair Lady* costumes, the actress at last found herself seductive. 'As far back as I can remember, I've always wanted to be beautiful', she wrote in her thank-you note to the photographer. 'Looking at these photos last night, I saw that, for a brief moment at least, I was … thanks to you.' Audrey was now very thin but her pale face radiated enormous energy. As usual, she threw herself into her role with rare professionalism and worked hard at her singing lessons. Unhappily, her efforts were not good enough; the singer Marni Nixon was called to the rescue to dub Audrey, who was distraught when she found out. For Audrey, Eliza Doolittle represented her 'first real character'; 'in other roles', she said, 'there's always been at least a little bit of myself; in this film, there is none.' Involving a raft of perfectionist professionals and a galaxy of technicians and accessories, filming was rather stressful. On 22 November 1963, cast and crew learned of the assassination of US President John F. Kennedy. The shy, slight actress stood on a chair to announce the news to the crew before dissolving in tears in her dressing-

room. Audrey was deeply affected by the news, not only because of her deep sensitivity, but also because she was going through a difficult time. She missed filming once or twice, slept poorly, lost more and more weight and quarrelled frequently with Mel. She was devastated when she learned that Marni Nixon would dub all the film's songs, not merely some of them. She subsequently turned down Michel Legrand's *Les Demoiselles de Rochefort* and Franco Zeffirelli's *Romeo and Juliet* and rested briefly in Switzerland before joining her husband, who was filming in France, Italy and Spain. When *My Fair Lady* was released, the reviews were unanimous – the film was a hit. A huge popular success, it was nominated for twelve Oscars, but Audrey was not included in the nominations. She was invited to present the Oscar for Best Actor, which went to Rex Harrison, while Julie Andrews won Best Actress for *Mary Poppins*.

Around this time, Audrey broke with her publicist, Henry Rogers, over Hubert de Givenchy. Rogers attempted to get payment from the couturier for the publicity Audrey had given him. When he tried to negotiate a contract, Audrey was taken aback. "You don't understand, I don't want anything from Hubert. I don't need his money. He is my friend. If I have helped him build his perfume business, so much the better. That's exactly what one friend would do for another. If someone else offered me a million dollars to launch a perfume, I wouldn't do it ... but Hubert is my friend. I don't want anything. Yes, I even want to walk into a drugstore and buy the perfume at the retail price,' she insisted, with tears in her eyes. She broke off professional relations with Rogers while he was negotiating her appearance at Cannes, but he insisted that Mel had much to do with his mercenary attitude. Tension between the couple was at its height when they moved to 'La Paisible', an eighteenth-century farmhouse that Audrey loved on sight. 'She wanted her privacy respected; as soon as she could, she moved away from Hollywood's limelight to Switzerland, where she could enjoy a simple life and be treated like everyone else. Switzerland is also a neutral country that hasn't been at war in over six hundred years, and that meant a lot to her', Sean would explain years later. Situated above Lake Geneva, fifteen miles from Lausanne, the Tolochenaz house was a haven of peace that enabled the Ferrers to reconcile. Sean would soon be going to school and Audrey hoped that her son would be able to learn French, which he quickly did; in addition to speaking Italian with Gina and English with his parents, he soon spoke perfect French and Spanish.

VII – From Albert Finney to Andrea Dotti, a renaissance crowned by Luca

At the point when Audrey's career was at its height, she decided to put it on hold. She wanted to spend more time with Sean and, although she had offers from top directors, she turned down many screenplays, with the exception of two: *How to Steal a Million*, with William Wyler, the director of *Roman Holiday*, to whom she always felt indebted, and *Two for the Road* with Stanley Donen. She started work on the Wyler film in 1965 and was paired with Peter O'Toole, the star of *Lawrence of Arabia*. The two actors were not very enthusiastic about the idea of working together. O'Toole had the reputation of being a dedicated seducer and a heavy drinker, while Audrey was famous for her simplicity, her professionalism and her discretion. Nevertheless filming was punctuated by the co-stars' shrieks of laughter and O'Toole was quickly touched by 'a modesty and melancholy' that he discovered in Audrey. 'She never referred to it but she seemed to be surrounded by a veil of

sadness. She tried to banish it by laughter, but as soon as the laughing stopped one sensed that her heart was on the point of breaking. I fell in love with Audrey Hepburn while shooting that movie', O'Toole confided. During filming, Audrey lived alone in Paris while Mel stayed with their son. The couple were not getting on, but Audrey struggled to save her marriage and rejoined Mel in Marbella, where they planned to build a new house.

In December 1965, Audrey learned that she was again pregnant. But fate was merciless and less than a month later she had another miscarriage. The shock was huge and Audrey, devastated, went to recuperate in Switzerland, where she rapidly came to the conclusion that she no longer had anything in common with her husband.

Her energy returned with the shooting of *Two for the Road*. She developed an immediate rapport with Albert Finney, who recalled never having had such intimacy with any other actress. Frederic Raphael's screenplay chronicles the wreckage of a twelve-year-old marriage – exactly the length of that of Audrey and Mel. The character of Joanna represented a real challenge for the actress: she had to play the evolution of a woman from eighteen to thirty. On the set, technicians helped in Audrey's metamorphosis – she was more extrovert, more natural and more lively, and Stanley Donen, although he had worked with her on *Charade* and *Funny Face*, didn't recognize her: 'She was so free, so happy. I never saw her like that – so young!' She joked and relaxed with the other actors. Albert Finney had quite a bit to do with the birth of this new Audrey. The two stars became lovers, but their affair didn't last beyond filming and Finney soon fell for the beautiful Anouk Aimée, while Audrey went dancing with the cast on the last day of filming and told a journalist: 'I love Albie. Oh, I really love him! He's terribly funny.'

In January 1967, she invited the Hollywood press corps to tea, appearing at her husband's side in a ravishing short orange dress. Shortly after, she started filming *Wait Until Dark*, produced by Mel and directed by Terence Young, famous for having directed the first two James Bond films. Audrey plays a young blind woman terrorized by a psychotic killer. To prepare for the part, she visited a centre for young blind people, spending days at New York's Lighthouse Institute for the Blind, finding her way around with a blindfold over her eyes. The atmosphere during filming was relaxed and Audrey organised a formal English tea every afternoon. Critics and public were enchanted with her break from ingénue roles.

For the fifth time, Audrey was nominated for an Oscar and, aged thirty-eight, she was again pregnant. But in September 1967, she lost her baby in the second month of pregnancy. She spoke with reserve about her miscarriages as 'a pain she had never felt before', Sean would relate.

She separated from her husband, finally facing the truth after having done everything to save her marriage. In winter 1967, she took Sean to Marbella for the holidays. She adjusted to her separation, stopped blaming herself and recovered her zest for life and freedom. The following summer, she joined the yacht of French businessman Paul Weiller for a Greek Island cruise. Also on board was a young doctor, a psychiatrist called Andrea Dotti. This well-born Italian had fallen for Audrey in *Roman Holiday* when he was fourteen, and had seen all of her films.

Audrey confided in Andrea a great deal and quickly developed a special rapport with him, especially since he got on well with Sean. For Andrea, this meeting was love at first sight. In November 1968, Audrey was divorced from Mel Ferrer and at Christmas Andrea proposed. Although attracted, Audrey knew how difficult it was to be married to an international star and she shrank from the possibility of having to face again the problems she had encountered with Mel. Nevertheless they were married in Switzerland in January 1969.

The newly weds then looked for an apartment in Rome and took over the first floor of a spacious palazzo. Audrey had all the energy of a young bride; to everyone's surprise, this former party-pooper danced all night with her new husband, who was a regular in the smartest clubs and restaurants. She turned down all the screenplays that continued to flood in and concentrated on decorating her apartment and leading a perfectly ordinary life – she was listed in the telephone directory, she went walking hand in hand with Andrea, went to the cinema without worrying about the paparazzi and lunched with girlfriends in popular restaurants. She tried hard to cut back her expenditure, but she was happy. The couple had a modest Fiat, although Audrey no longer drove following a traumatic incident in the 1950s. Andrea quickly realized that he had married a simple woman rather than a movie star, but he was happy to see Audrey so relaxed. Four months after their wedding, she was pregnant and Andrea was thrilled, having told her during their cruise that he wanted lots of children.

Throughout spring and summer 1969, Audrey secluded herself in a holiday home owned by the Dottis, who got on very well with their daughter-in-law. In September, she returned to La Paisible instead of going back to Rome, and Luca was born in February 1970 in a Lausanne hospital. Andrea was a delighted father and Sean, now aged ten, was thrilled with this new little brother. Audrey was very happy; not for a moment did she think of returning to the pressure of the studios. 'At one point in my life, I had to make a choice', she declared in 1988, 'to give up films or give up my children. It was a very easy decision to make because I missed my children terribly. When my elder son went to school, I couldn't take him with me, and that was very hard; I refused to do films in order to stay home with my children. I was very happy. It wasn't that I spent my days sitting around doing nothing, frustrated and biting my nails. Like every mother, I adored my two sons.' The only shadow came from Andrea; although he was a wonderful father, he also liked to party and simply could not give up the nightclubs. As Audrey now refused to stay up until dawn, he went out alone, or more often accompanied by pretty women, something the gossip columns were quick to seize upon.

In 1971, Audrey renewed contact with Mel, who had remarried in London in February. His new wife was Elizabeth Soukhotine, a children's book editor. Audrey made a brief return to the cinema for *A World of Love*, a TV documentary produced by UNICEF and featuring Barbra Streisand, Richard Burton and Harry Belafonte. This was her first work for the United Nations Children Fund. She next filmed the one TV commercial of her career, an advertisement for Japanese wigs. Audrey was fascinated by Japan, where she was much admired. Shortly afterwards, she began to get intimidating telephone calls and threats to kidnap her children. At that time, Rome was suffering a wave of violence and terrorism, and she decided to follow the example of Sophia Loren and Carlo Ponti by removing her children from the Italian capital. She returned to Switzerland, joining Andrea only for weekends, with significant consequences for their relationship. In Switzerland, she still led a quiet life. 'We grew up as normal kids', wrote Sean. 'We didn't grow up in "Hollywood", not the place, not the state of mind. Our mother never watched her own films. Once they were done, that was it. So we weren't a "show biz" family. I didn't grow up surrounded by filmmakers and I didn't play and go to school with their kids.'

Audrey returned to the cinema, starring alongside Sean Connery in *Robin and Marian*, directed by Richard Lester, and being paid nearly $800,000 for her comeback. She filmed in Spain during school holidays, rejoining her husband in Rome at weekends. Andrea Dotti's nocturnal life fed the gossip columns, while Audrey told journalists, 'I take care of my health, and this world takes care of my thoughts.'

In 1978, her son Sean, aged eighteen, had just finished work on his first film. Audrey decided to take him to the dance and theatre festival at Spoleto, a medieval town on the border of Tuscany and Umbria. 'During the production, which kept me employed for almost a year', Sean explained, 'I had grown a beard. I guess I didn't want everyone to know that I was only eighteen. So the paparazzi caught up with us in Spoleto and got a few snaps of us hurrying in to an evening performance. The next day the picture was printed in the papers with the following headline: "Audrey with the new love of her life." When we saw it, we both laughed, realizing that they had no idea who I was. She said "Well, apart from the 'NEW', for once they got something right." She cut it out and framed it.'

Audrey next agreed to appear in *Bloodline*, directed by Terence Young, for which she signed a million-dollar contract. The film was released in 1979 and the reviews were disastrous. Audrey was very shaken and her self-confidence received a bad knock. She joined Andrea for a trip to Hawaii, but the couple faced facts and discussed divorce.

Despite the fiasco of her last film, Audrey accepted a new screenplay, *They All Laughed*. The part was written for her by director Peter Bogdanovich; her character was a spiritual woman, at once strong and fragile. Her co-star was the Italian-American actor Ben Gazzara, with whom she had a brief liaison. The press hastened to report the scoop, denied by Audrey, who found herself very alone when filming ended, being comforted by her friend Bogdanovich, described by Barbra Streisand as 'a horny bastard, but brilliant'. Audrey adored him and he returned her adoration, seeing in her everything she hadn't managed to conceal – the open wounds, the vulnerability. 'She was a survivor, but it was painful', he said. 'There was a sense of lost gaiety around Audrey that she could never quite recapture. I felt that it was from all the guys who had treated her badly. ... I sensed that this would be her last film, which is why I did the ending as a montage of all those shots of her. I felt it was a farewell to that Audrey Hepburn. As the helicopter took her away, I thought, "The world is taking her away." The fun had gone out of it for her. She didn't think it was important anymore.' And, in fact, from now on the important thing would be elsewhere.

VIII – Robert Wolders and 'all the world's children': *An elegant spirit*

In 1981, Audrey and Andrea had a marriage in name only. Her husband's escapades were well-known but, until then, Audrey had put up with this tacit arrangement to preserve her family life, even though she had never liked the situation.

When Robert Wolders entered her life, thanks to her friend Connie Wald, Audrey was fifty-two. Robert, who was seven years younger, was nothing like her previous attachments; as well as being handsome, he was gifted with rare sensitivity and, like Audrey's, his was a wounded soul. He too had spent the end of the war in a suburb of Arnhem and his memories were the same as Audrey's. Robert immediately saw that the actress had been unhappy in love, but he was captivated and remained patient. He became first her confidant, then her friend ... and Audrey fell in love while still believing it couldn't happen to her again.

Robert Wolders had an unhappy romantic past, about which there had been much tabloid coverage, but for the first time Audrey felt secure with a man. In April, she no longer bothered to hide her happiness from the media, declaring simply 'I love him and I'm happy'. The separation from Andrea was managed discreetly and they remained good friends, both watching over Luca's education. Audrey recovered all her gaiety; she began to go out again, and the paparazzi returned.

Audrey and Robert began living together in 1981 and the following year her divorce was finalized. Comforted by her new companion, she mourned the death of her friend David Niven in 1983, followed by that of William Wyler and, above all, of her mother a year later. During these years, Audrey also became close to Doris Brynner, who owned a property close to La Paisible. With Robert by her side, she spent quiet years, rising at dawn and strolling peacefully in the village when she was not gardening. Robert got along well with Sean and Luca, and the couple's friends could only rejoice at their obvious happiness.

Audrey played the star when necessary; she signed copies of *Gardens of the World* at Ralph Lauren in New York and seemed very surprised at the endless queue: 'I had to leave by the back door because of the crowd', she complained. 'I regretted it because I'd left all those people waiting outside for ages.' In 1987, she agreed to make a TV movie, *Love among Thieves*, in which she played a pianist in love, forced to deal with thieves to recover her kidnapped fiancé. But the 'living legend', as she was now called, no longer made films; from now on UNICEF would fill her life. 'Audrey's career can be divided into two chapters', said Leslie Caron. 'In the first, she had all the acclaim you could possibly dream of, and in the second, she gave back in spades what she had received.'

In March 1988, Audrey suggested to Christian Roth of UNICEF that she should work with them for a year. In fact, she was about to embark on a decisive stage of her life. She went to Ethiopia, and was shocked: in Eritrea and Tigre, she discovered disaster and misery, and was haunted by the faces of children disfigured by famine. Overwhelmed and revolted, she returned to hold a press conference in London. She was appointed a goodwill ambassador for UNICEF and embarked on a series of trips, accompanied by Robert, visiting Turkey, Venezuela and Ecuador in 1988, Guatemala, Honduras and El Salvador in 1989, followed by Mexico, the Sudan,

Thailand and Bangladesh. For once, Audrey felt that celebrity had its uses. As always, faced with awards and journalists, she was modest, reminding them that the cameras were on her because she was an actress, while the aid workers, who did extraordinary work, remained in the shade. 'Although she was never an ardent follower of any formal religion', her son Sean said, 'my mother's own faith endured throughout her life: her faith in love, her faith in the miracle of nature, and her faith in the goodness of life. She honoured this second chance at life at every opportunity that presented itself and most of all at the end of her life, through her work for UNICEF. Sometimes it was highly dangerous to deliver parcels of foodstuffs. At such moments, one knew the full meaning of life.'

From the beginning of her work with UNICEF, Audrey immersed herself in reports and books. 'I don't believe in collective guilt, but I do believe in collective responsibility' was her creed. She battled for recognition of the Convention on the Rights of the Child and found some comfort in the existence of television, which could bring images of suffering from the other side of the world into people's living-rooms.

In the mid-1980s, Audrey learned that her father was gravely ill. Although she had helped him financially ever since she and Mel had sought him out in Ireland, she had seen him only once since that Dublin visit. '... he came to La Paisible, our home in Switzerland, for a day or two', wrote Sean. 'I believe it may have had something to do with my mother's desire that he meet me and see where we lived.' Now Audrey went to see her father, accompanied by 'Robby'. 'Yet he still couldn't address those important life issues. Instead, he spoke of his horses, although he didn't have any by that time. ... Still unable to connect with his daughter, he told Robby how much she meant to him, how he regretted not having been more of a father figure, and how proud he was of her.' Audrey left Ireland a few days before her father died. According to Sean, 'This time she never looked back. ... As far as she was concerned, her "father" had died long before, and she had buried him then.'

Audrey took a cameo role in *Always*, directed by Steven Spielberg, whom she admired greatly. She played a guardian angel to Richard Dreyfuss, and during filming she met up with Gregory Peck and other friends. This small role rekindled her taste for acting, and in 1991 she appeared at the Barbican Hall in London, narrating *From the Diary of Anne Frank* with music by Michael Tilson Thomas played by the London Symphony Orchestra. From now on, she would always be willing to put herself at the service of suffering.

Audrey took part in further performances of the production in Philadelphia, Miami, Chicago, Houston and New York. In 1992, the Princess Royal presented her with the British Film Academy's special award in London, and later the Lincoln Center's Film Society of New York organised a gala tribute in her honour, where Audrey joined the thirty or so actors who had received this honorary award – Charlie Chaplin, Fred Astaire and Alfred Hitchcock, among others. On returning to Switzerland, she considered other film projects suggested by various studios, but her heart wasn't in it. At sixty, she still received hundreds of proposals, but only UNICEF motivated her. 'My great ambition is to have nothing to do but simply to stay at home, devoting myself to my tomatoes and my roses, looking after my dogs', she said, 'and one day I'll do it, but not yet, not until I'm sure that I know that "my children" in all

countries are well treated.' It took her a year to get the necessary funding for a trip to Somalia and the green light from UNICEF. She tried to get visas and was told 'There are no visas, because there is no government. You just fly in and hope you won't get shot down.' It was the early 1990s – the world knew almost nothing about the genocide and the Somali refugee camps.

When she returned from Somalia in 1992, Audrey told her son: 'I have been to hell and back.' She called a press conference to share her rage with journalists. The actress still had memories of World War II. In 1945, she had heard the whole world saying 'Never again', but on returning from Somalia she was agonised, telling close friends that in Africa the holocaust was an everyday event.

Audrey's press conferences were brilliant. Undoubtedly they were fuelled with idealism, but they were also packed with facts that she had gathered on the ground, and filled with the modesty and humanity that characterised her. 'Ideally, politics should act against human suffering. It's my dream. And this is why I take this example, because it may be unique in history: humanitarian aid is all that's keeping Somalia afloat. I think perhaps with time, instead of there being a politicisation of humanitarian aid, there will be a humanisation of politics. I dream of the day when these two notions will come together. That is one of the reasons why I wanted to visit Somalia, not because I could do anything much, but there are never too many witnesses. If I can be another, speaking in the name of a child, it's worth it all.' UNICEF's goodwill ambassadress made her point and her battles were widely reported by the press.

When she returned from Africa, Audrey complained of abdominal pains. She did not tell her children; only Robbie knew about it. She underwent medical examination in Switzerland and the results were not encouraging. In October 1992, while she was in Los Angeles, she had further tests and was operated on in November. Two hours into the operation, the surgeon announced that he had discovered an abdominal cancer (or 'abominable' as Audrey called it thereafter, playing it down). She was told that the cancer had begun in her appendix and had evolved slowly, possibly over five years. 'We had ... seen photos of the children in Africa who, on the verge of death, are put on an IV drip because of severe dehydration. She was now one of them', wrote her son Sean.

A week later, Audrey left hospital to recuperate at the house of her friend Connie Wald, where she usually stayed while in Los Angeles. She began chemotherapy, experiencing no side-effects, but a week later a new bowel obstruction was discovered. 'We'd had but a few days of hope, careful walks by the pool', Sean said, 'and nights of watching television, all of us sitting on the floor around her bed, watching comedies ... and nature shows She spoke of how much she enjoyed them. They reassured her that the miracle of nature was still well and alive and that life, with its beautiful simplicity, would continue no matter what. The doctors wanted her back in surgery ASAP. December 1, 1992, was the hardest day of my life. We were preparing to take her back to the hospital, and as everyone rushed around, carrying out their respective duties, we had a moment alone in her bedroom. I was helping her to get dressed when it all rushed to the surface and flooded her. ... As I held her tight, she whispered "Oh, Seanie, I'm so scared." I stood there, holding her with all my might, as I felt huge chunks of me falling inside.'

The press published alarmist prognostications, which her family tried to hide from her. Attempting to protect his mother from the paparazzi, Sean took his old convertible and laid her in the back for the drive to the hospital. Less than an hour into surgery, the surgeon told Audrey's family that the cancer had evolved exponentially: medicine could do nothing more for her.

Sean rejoined his mother in her room. Audrey was peaceful. When he told her that her condition was too critical for surgery, 'She looked away and calmly said, "How disappointing". That was it.'

Audrey spent several weeks at Connie Wald's gathering strength, then Hubert de Givenchy organised her return to Switzerland. All she wanted was to go home. A close friend of Givenchy placed a private jet at her disposal, as it seemed impossible to transport her on a commercial airline. Doctors had warned that she might succumb to the aircraft's decompression in less than an hour.

However, on 19 December 1992, having said goodbye to Billy Wilder and James Stewart, Audrey was taken to the airport and flew to Switzerland. She was happy to return to her home, La Paisible. Despite the gravity of her state of health, she tried to spend some time in her garden every day, but she was stalked by paparazzi and their helicopter soon deprived her of her pleasure in the fresh air.

The family spent Christmas at La Paisible. Audrey, far too weak to go shopping, gave everyone a personal memento. One night, she turned to Robby for a last word of love, telling him, 'You're the best husband I ever had, even if it's not official.' When her son Sean spent the night at her bedside, she woke and he saw her looking pensive. 'I had asked her about her thoughts and her feelings. ... She didn't reply. And then I asked her if she had any regrets. She said, "No ... but I cannot understand why so much suffering ... for the children." And after a while she added, "I do regret something. I regret not meeting the Dalai Lama. He's probably the closest thing to God we have on this earth. So much humour ... so much compassion ... humanity." Those were her last words before she fell back into sleep.'

On 20 January 1993, Audrey Hepburn died at home, surrounded by Robert, Sean, Luca, Mel and Andrea. She was buried in her little village, where personalities from all over the world showered her with flowers. 'I keep thinking of her funeral', recalled her closest friend Hubert de Givenchy, 'it was so like her, so simple, so fresh, in the presence of all those she had loved, famous or unknown. The whole world was united in tenderness and love. Despite the difficulties of life, Audrey always knew how to preserve in herself a part of childhood. And this magic, she spent her life trying to give it to us. It's that which made her an enchantress, a gentle, inspiring magician of love and beauty. Such enchantresses don't wholly go away.'

Axelle Emden

«My father walked out on us. All my personal relationships have been marked by this sense of abandonment, which has never left me.»

Audrey Hepburn

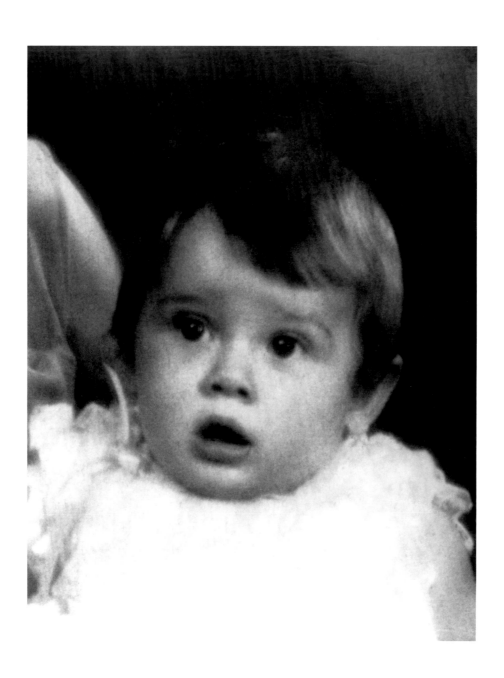

1930 / Audrey Hepburn at just one year old.

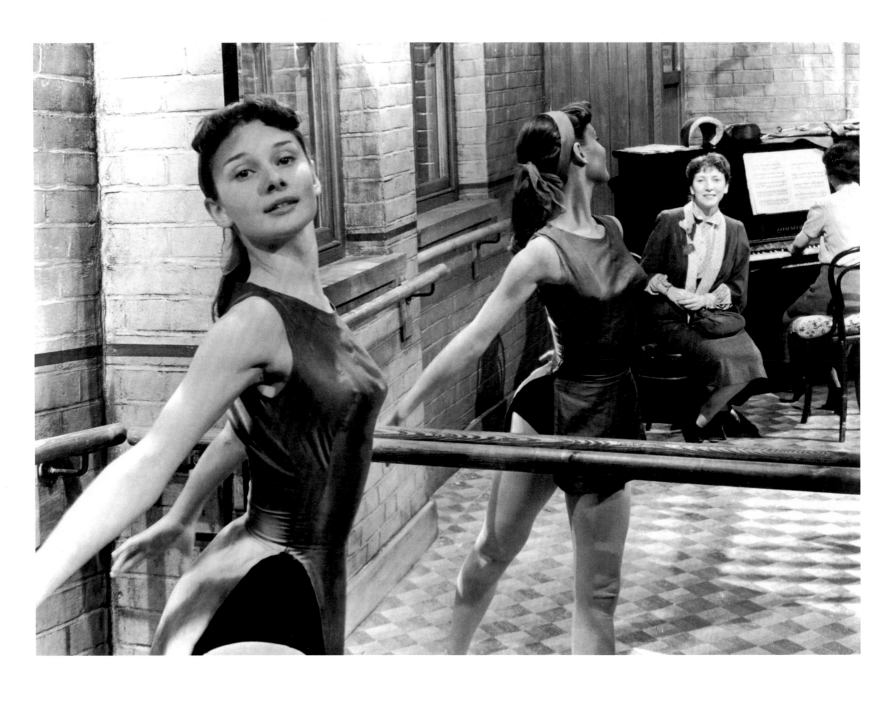

1952 / Audrey was only 22 when she played a young dancer in *Secret People*, directed by Thorold Dickinson.

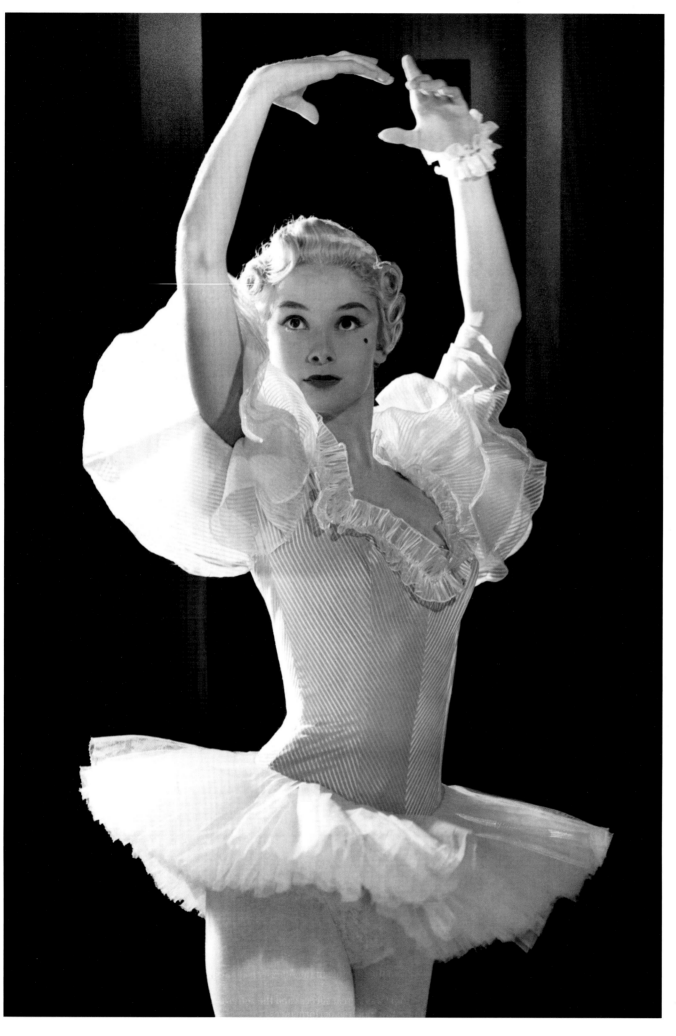

1952 / Audrey had dreamed of becoming a prima ballerina; in *Secret People*, she combined her two passions, ballet and cinema.

1951 / Paris, France / Colette expressed the personal hope that Audrey Hepburn would be given the title role in the American adaptation of *Gigi*.

1952 / Audrey starred in a stage version of *Gigi*. The Broadway dress rehearsal (November 1951) was a great success and the actress received rave reviews in the *Herald Tribune* and the *New York Times*. The play would run for two hundred performances.

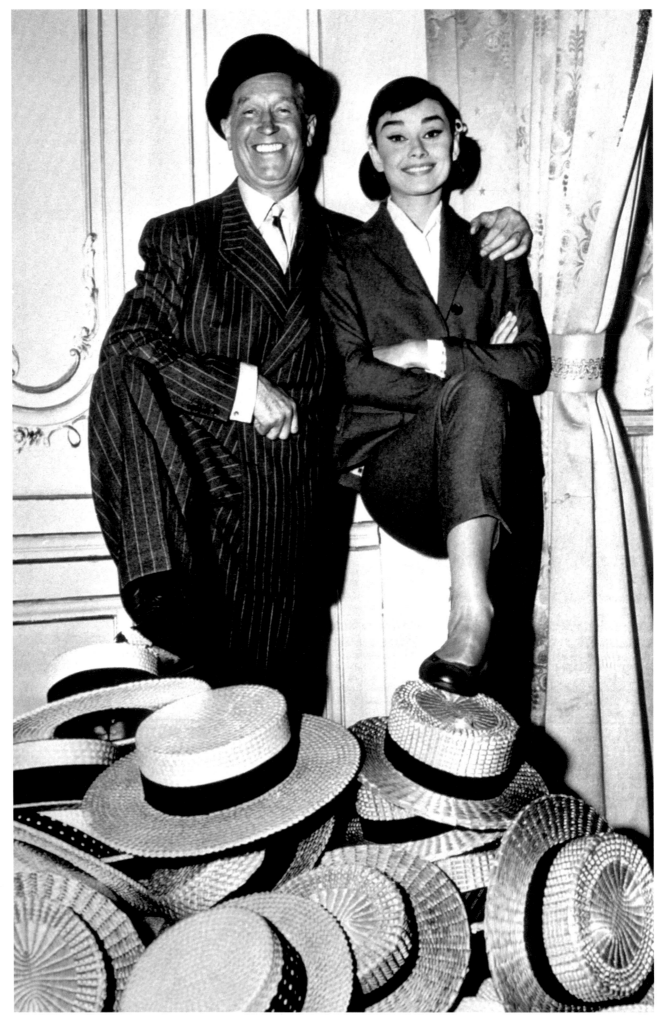

1957 / Maurice Chevalier poses with his young partner on the set of *Love in the Afternoon*, directed by Billy Wilder.

1957 / Audrey played the female lead in *Love in the Afternoon*. Billy Wilder's film received three Golden Globe nominations: best film, best actor (Maurice Chevalier) and best actress (Audrey Hepburn).

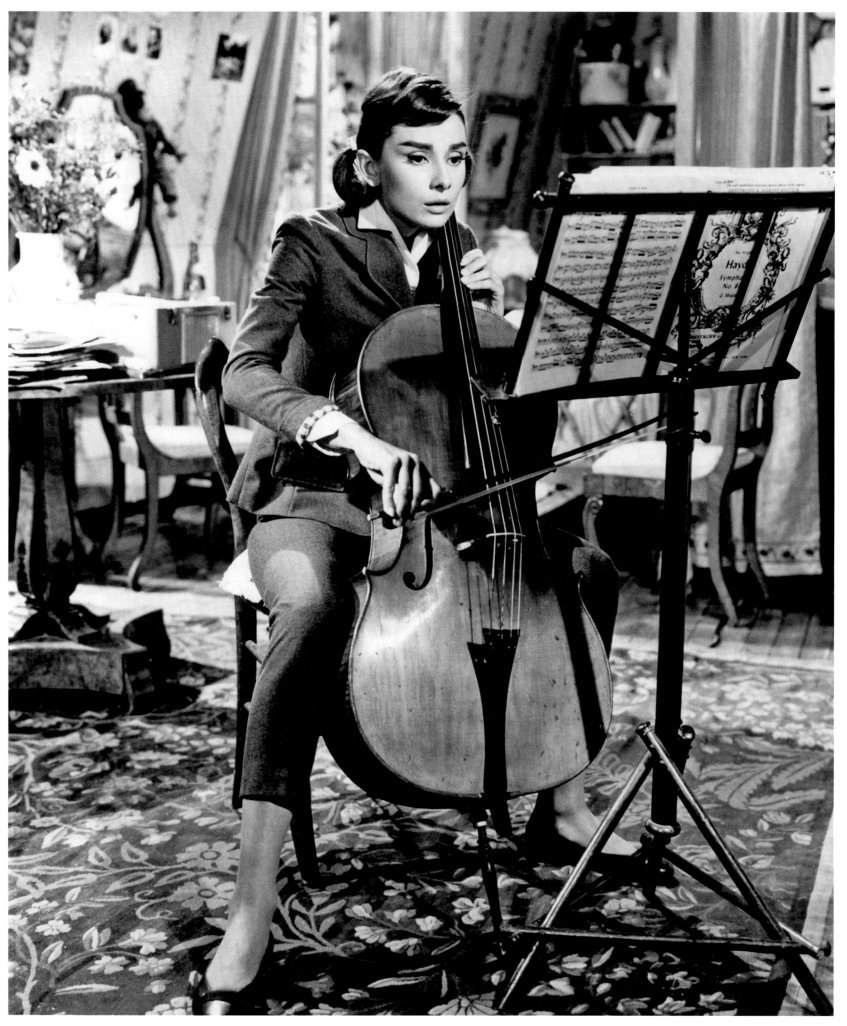

« I don't want to be alone, I want to be left alone.»

Audrey Hepburn

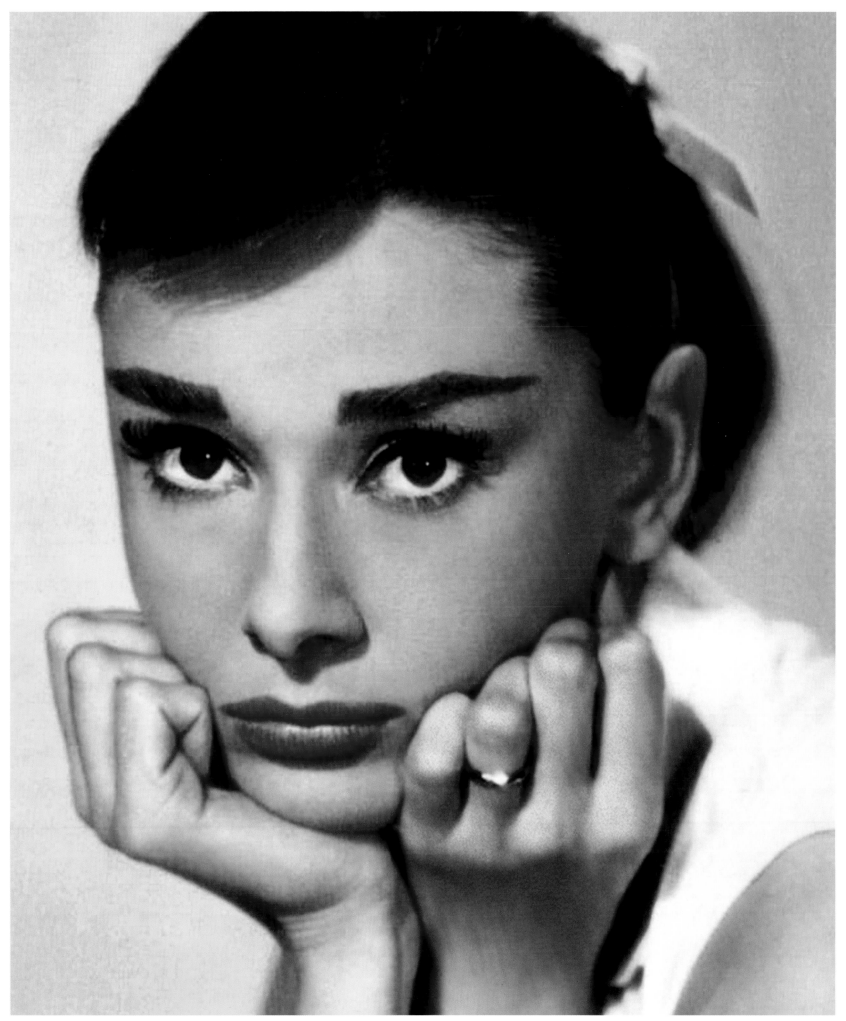

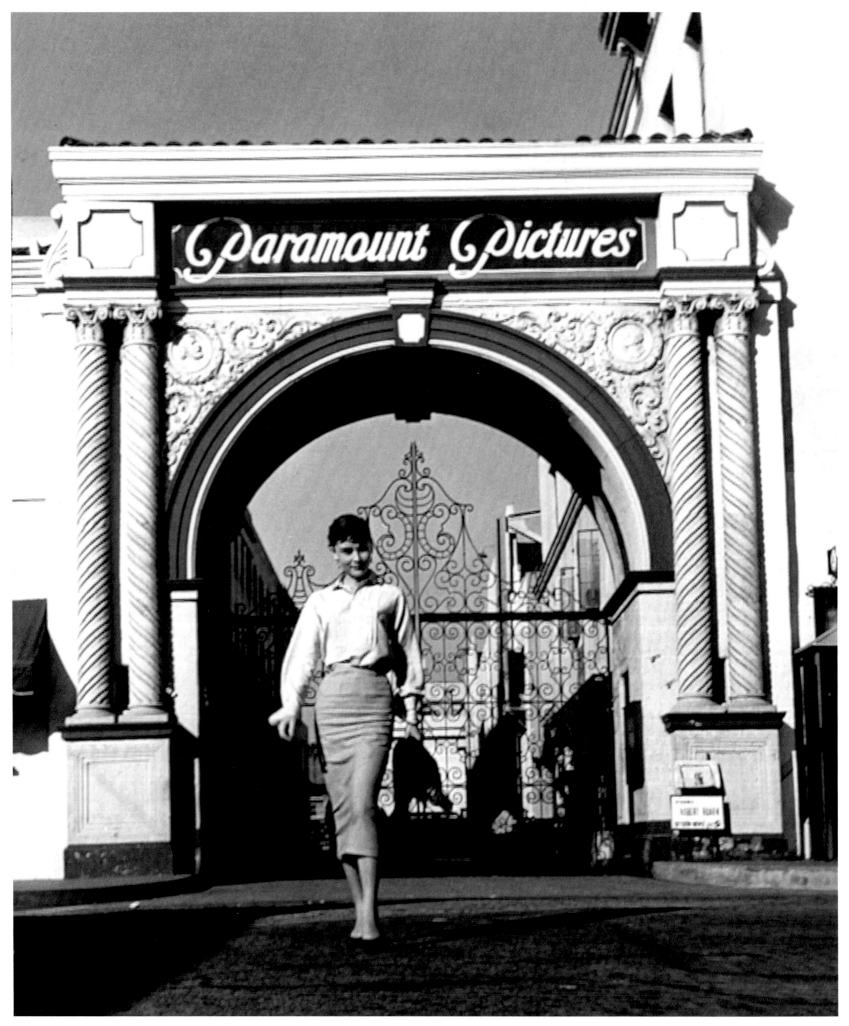

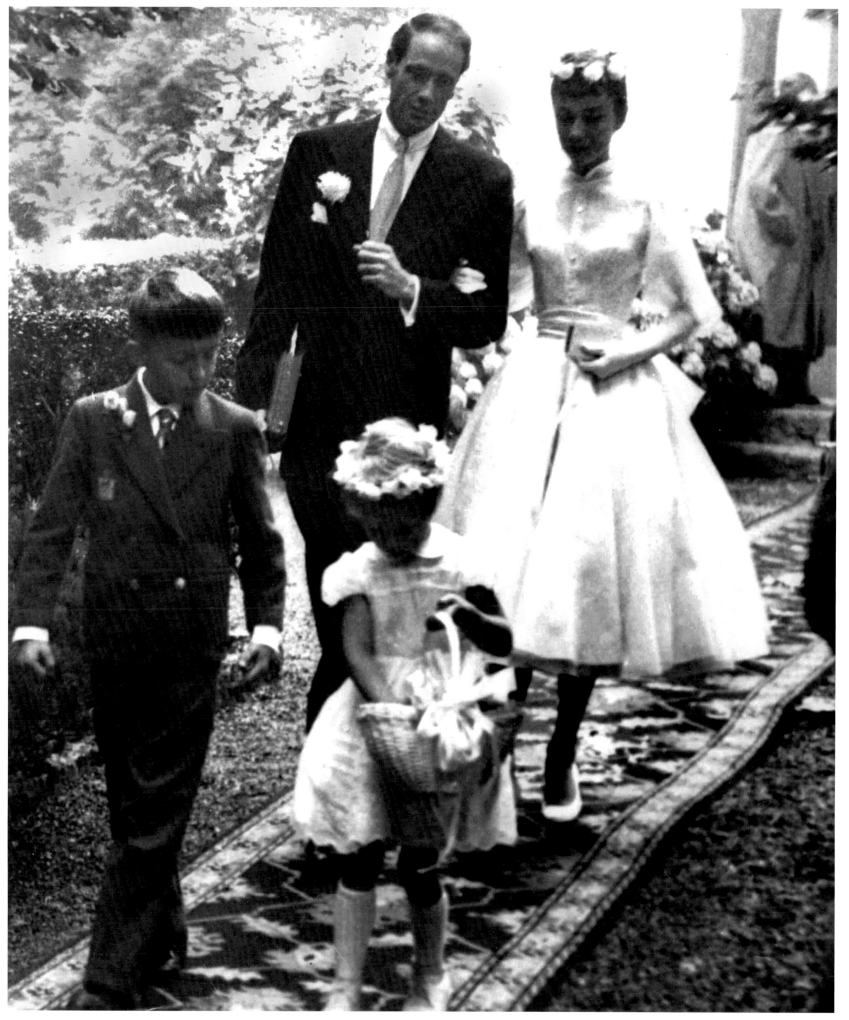

« As a child, I was taught that it was bad manners to bring attention to yourself, and to never, ever make a spectacle of yourself… All of which I've earned a living doing. »

Audrey Hepburn

Previous pages :
1952 / Audrey Hepburn trying on a dress for her anticipated wedding with James Hanson.

25 September 1954 / Audrey, aged 24, marries Mel Ferrer, 13 years her senior, in the small chapel in Bürgenstock near Lake Lucerne.

44

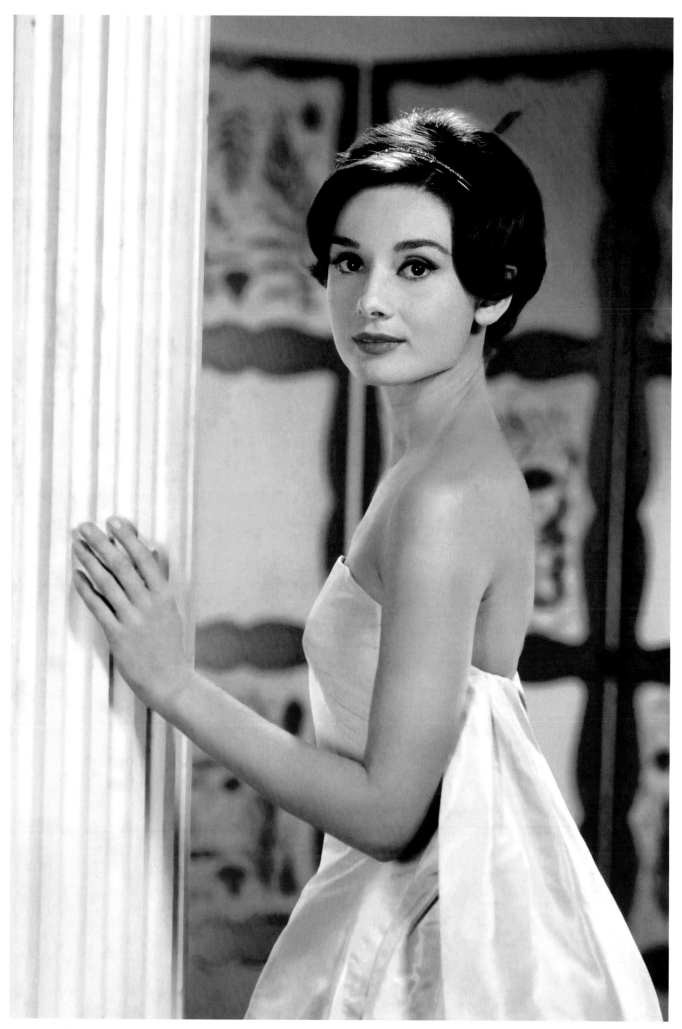

1958 / Audrey aged 29.

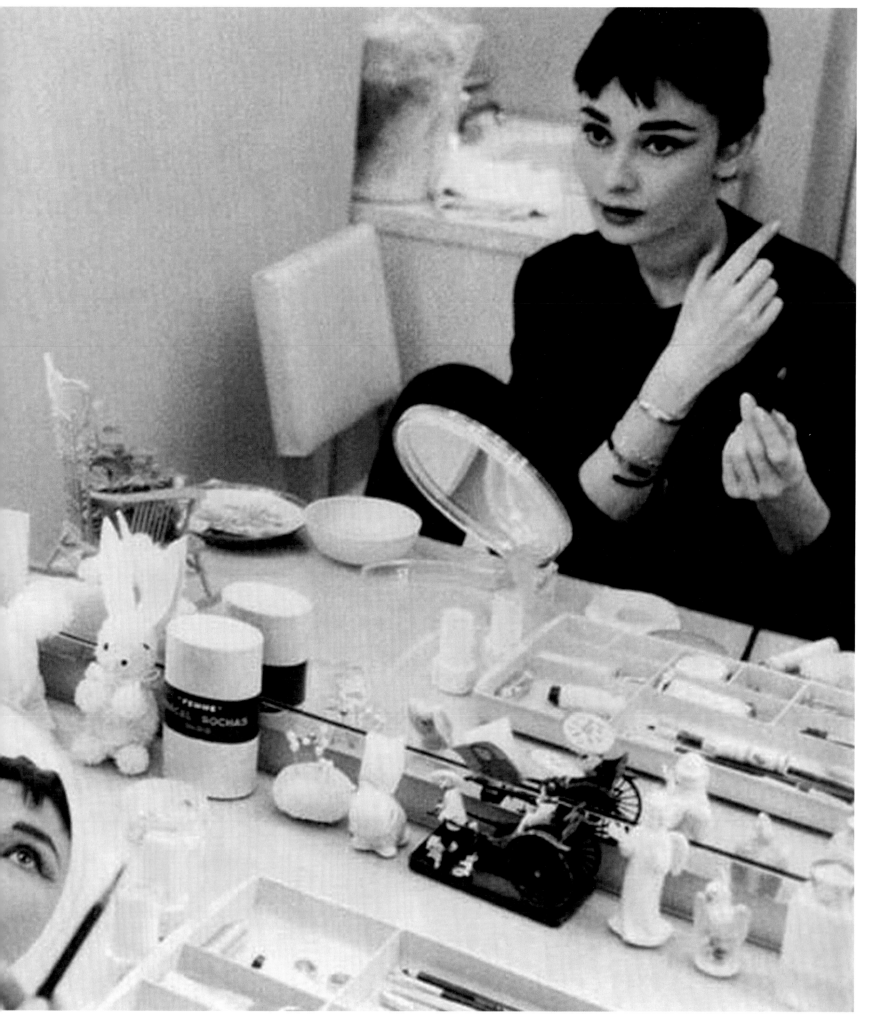

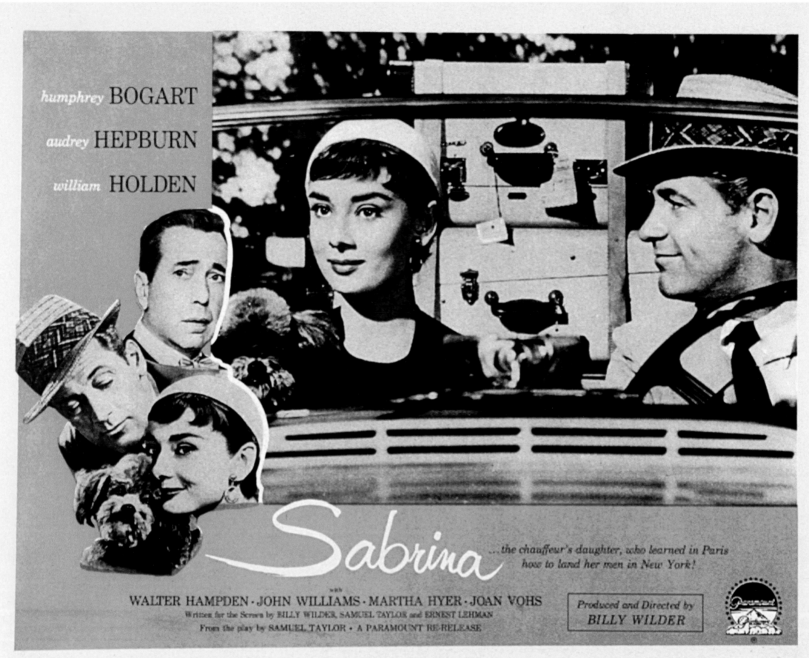

Previous pages :
1954 / New York City / Make-up session before shooting a sequence from SSabrina.

1954 / Poster for *Sabrina*, distributed by Paramount; Audrey shared the billing with Humphrey Bogart and William Holden. She had a brief affair with the latter.

48

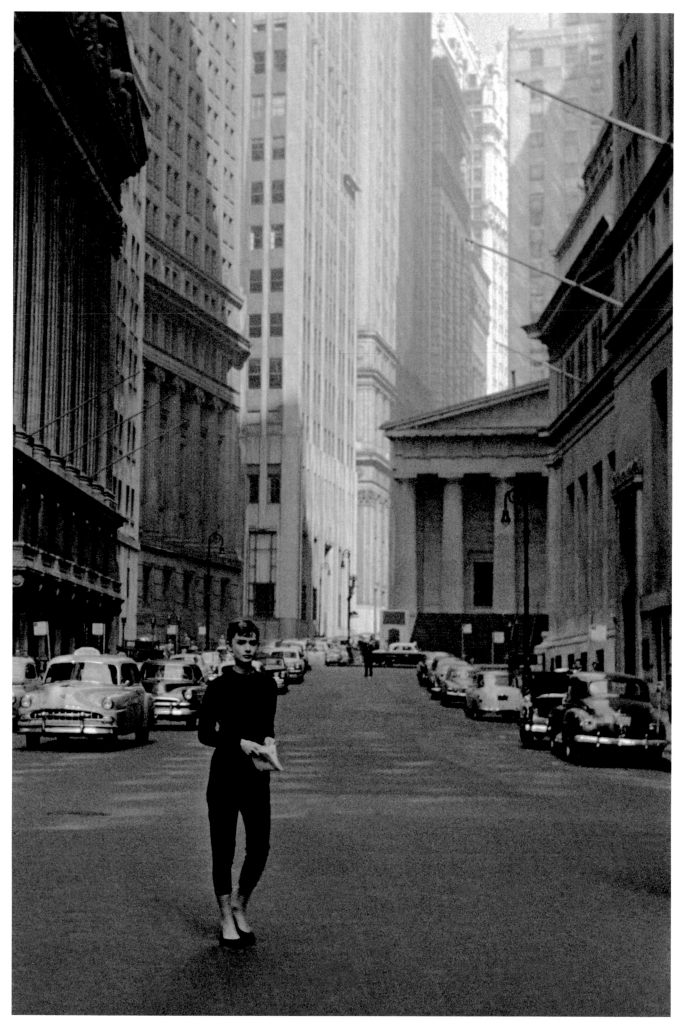

1954 / New York City / Audrey takes a stroll in the vicinity of Wall Street.

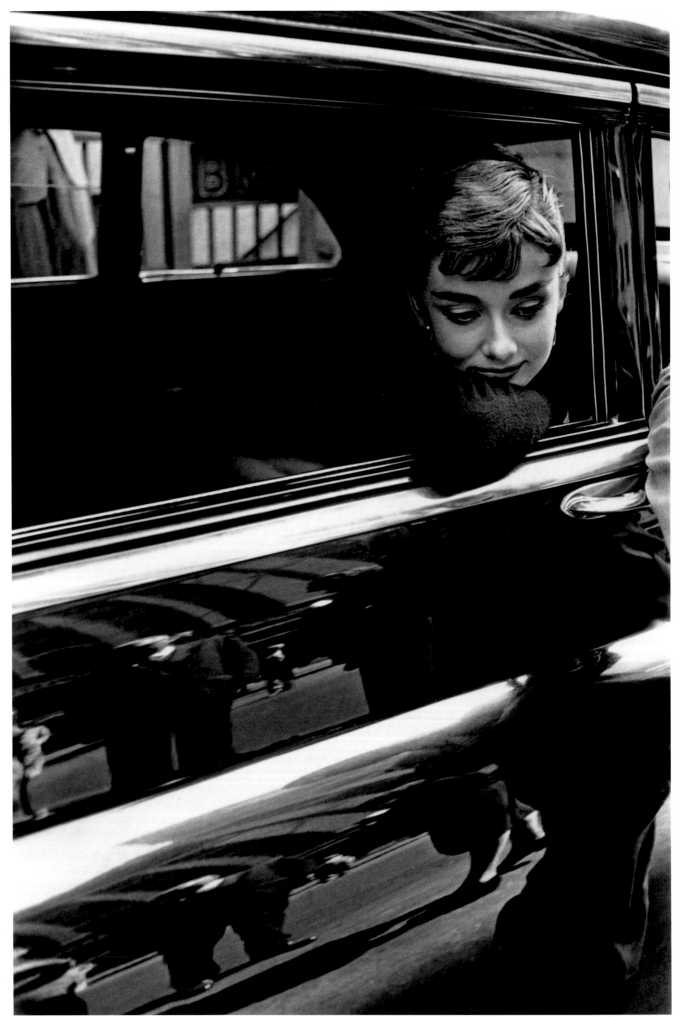

1954 / New York City /
During filming of *Sabrina*,
directed by Billy Wilder.

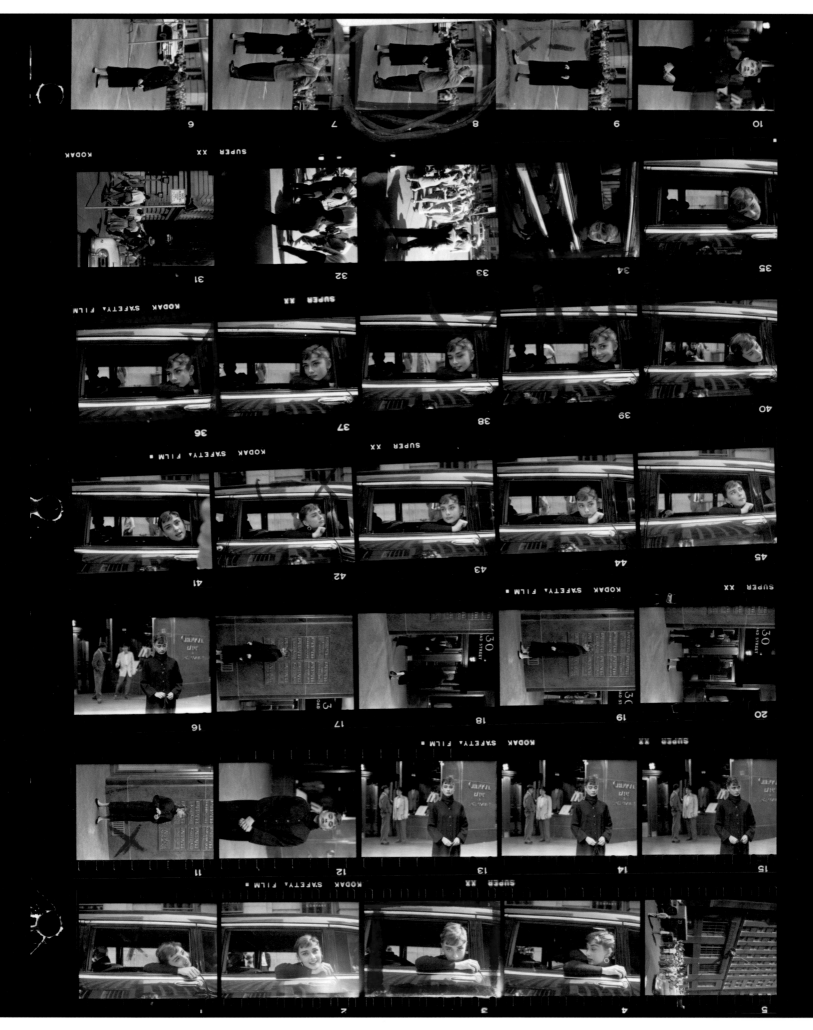

51

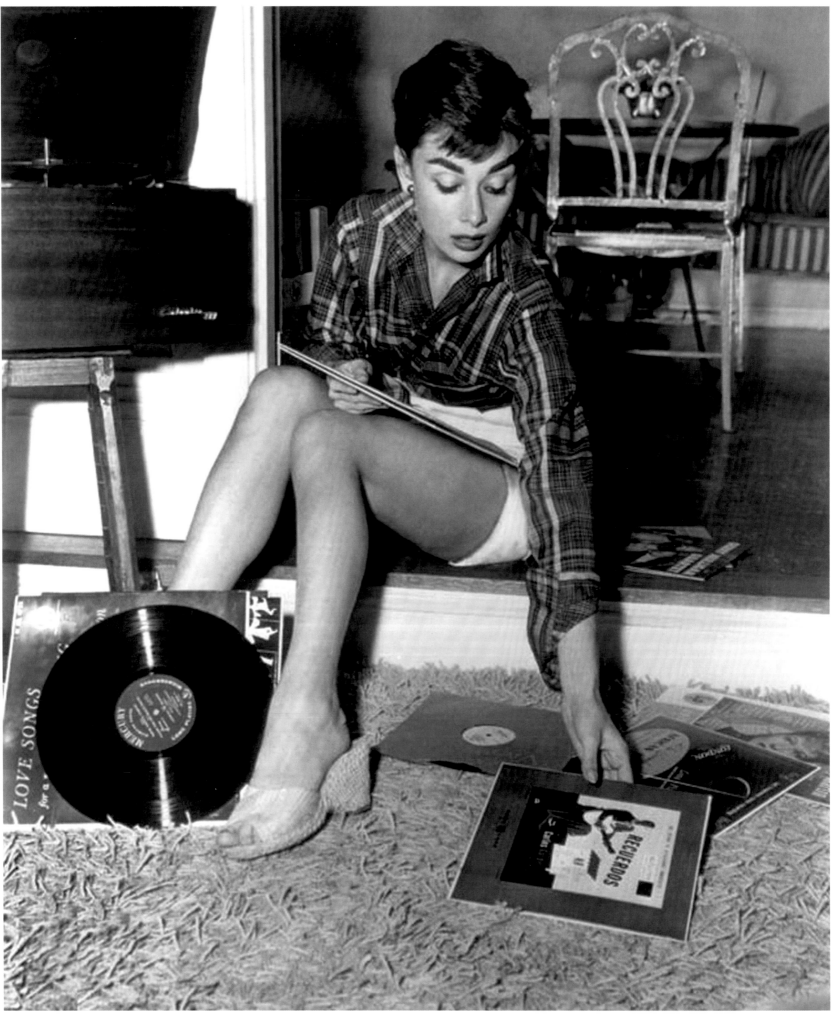

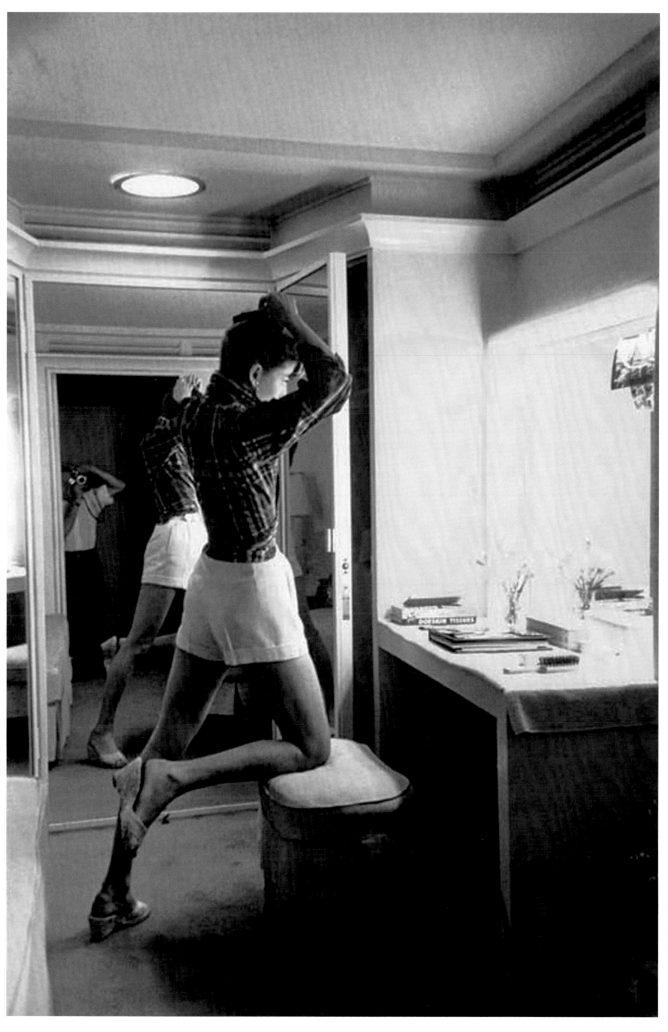

1953 / Los Angeles, CA / Audrey at home. At only 23, she is about to become a star, winning an Oscar for *Roman Holiday*.

1954 / New York City / During the filming of *Sabrina*, Mark Shaw makes the most of a dressing-room photo session with Audrey.

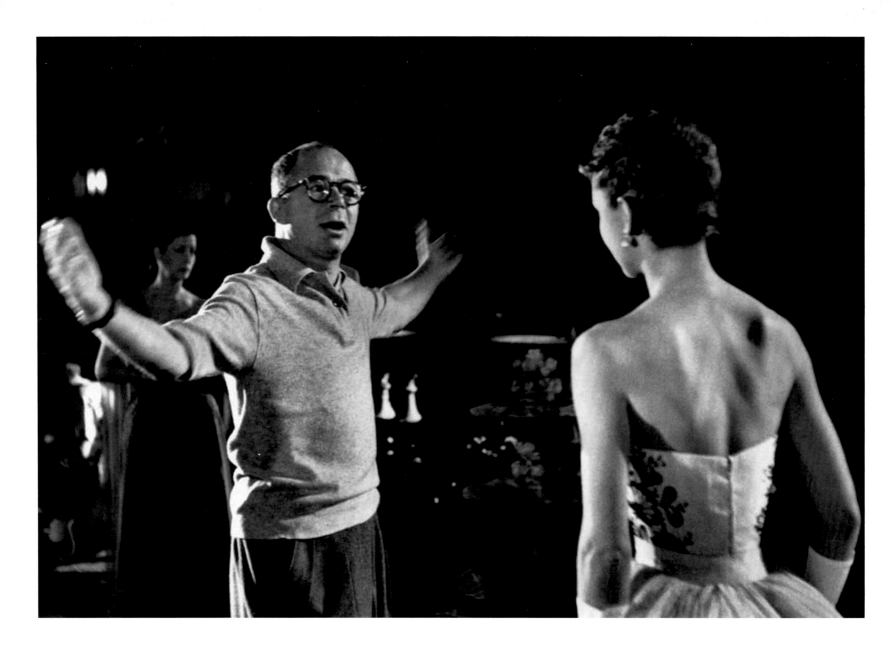

1954 / Los Angeles, CA / Billy Wilder directing Audrey between takes.

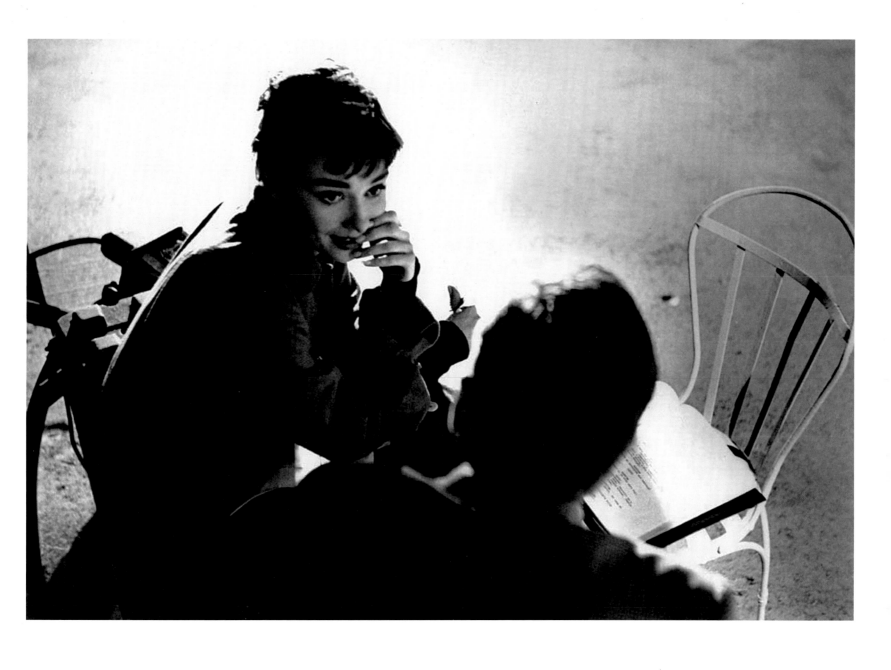

1954 / Los Angeles, CA / On the set of *Sabrina:* Audrey and William Holden discussing the script before a take.

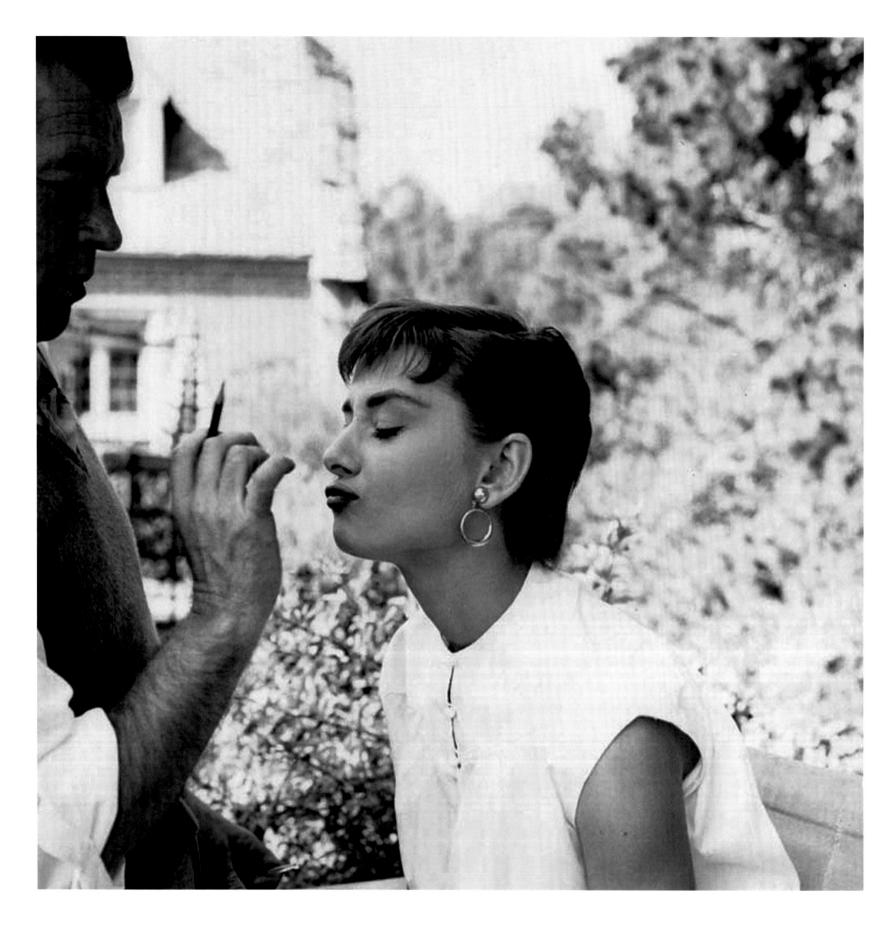

1954 / Long Island, NY / Audrey making up before a scene from *Sabrina*.

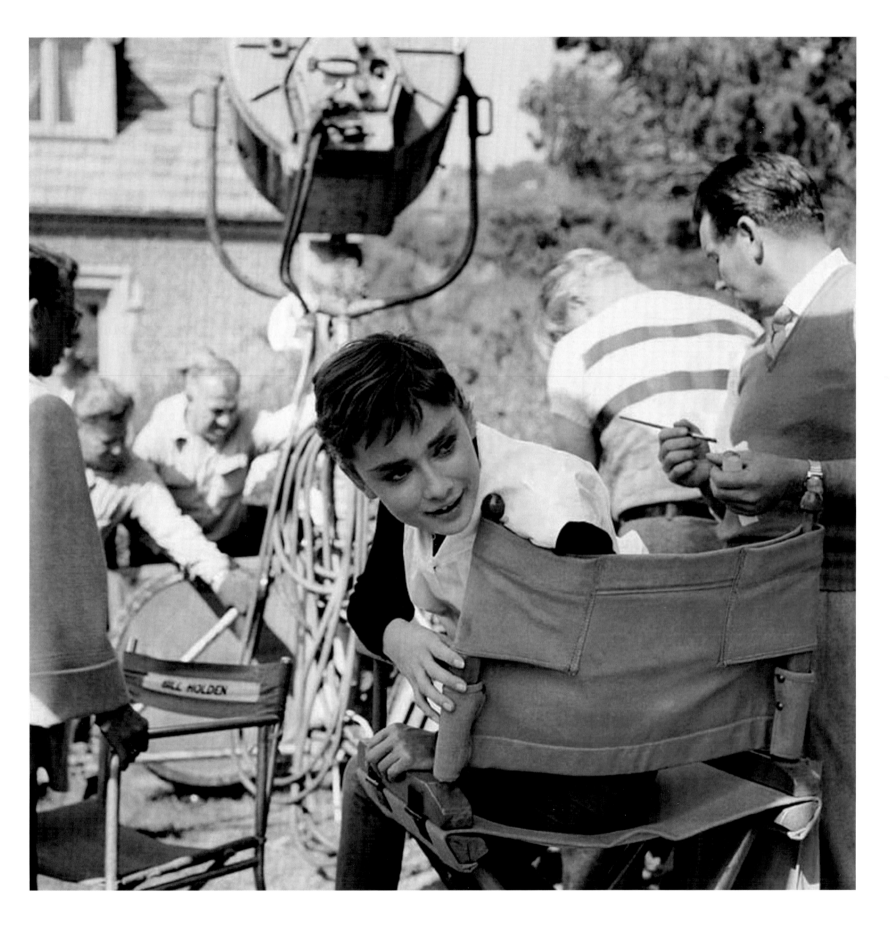

1954 / Long Island, NY / Audrey on the set of *Sabrina*.

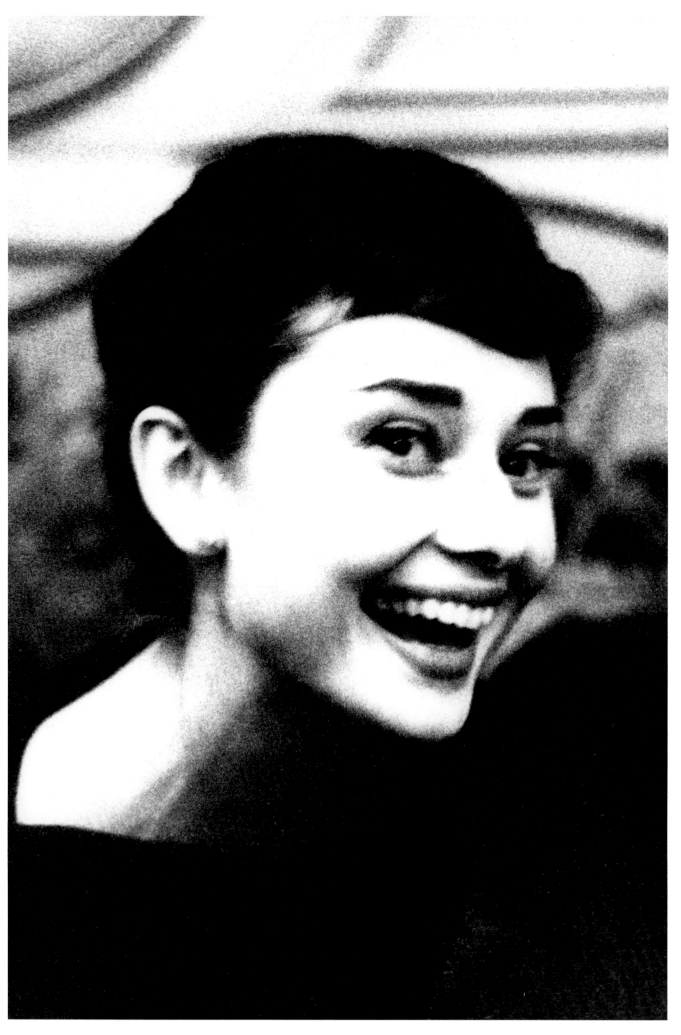

1953 / Audrey Hepburn aged 24.

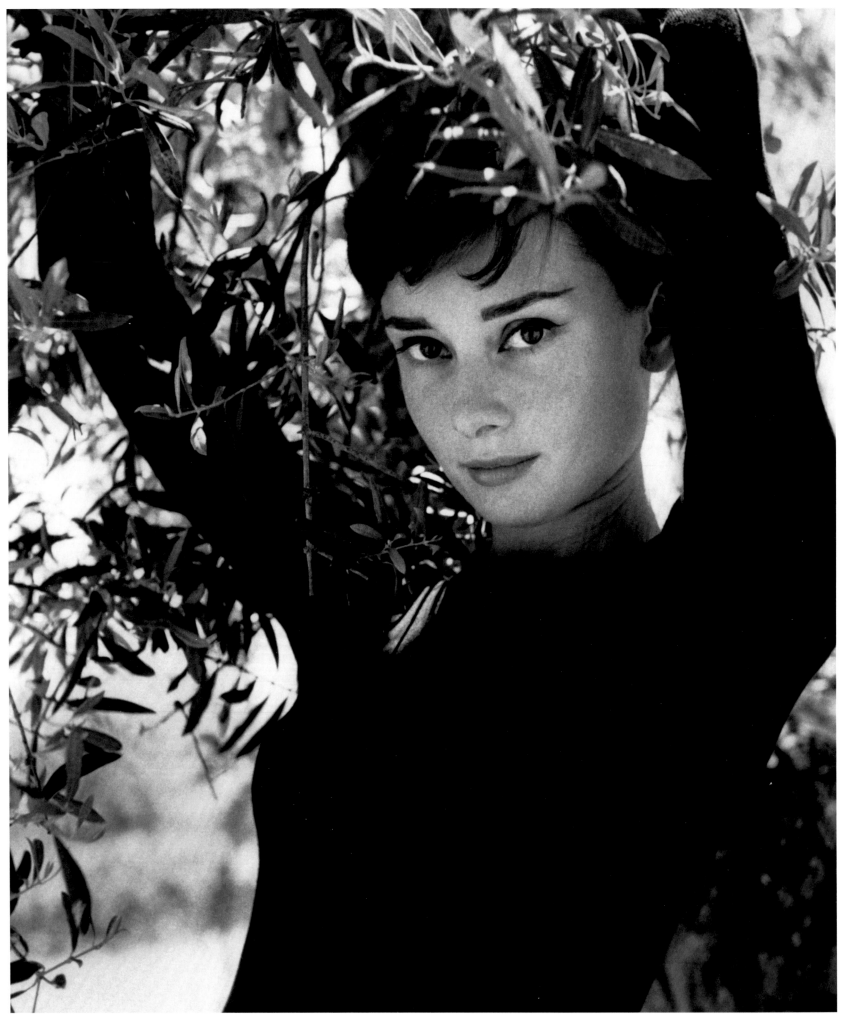

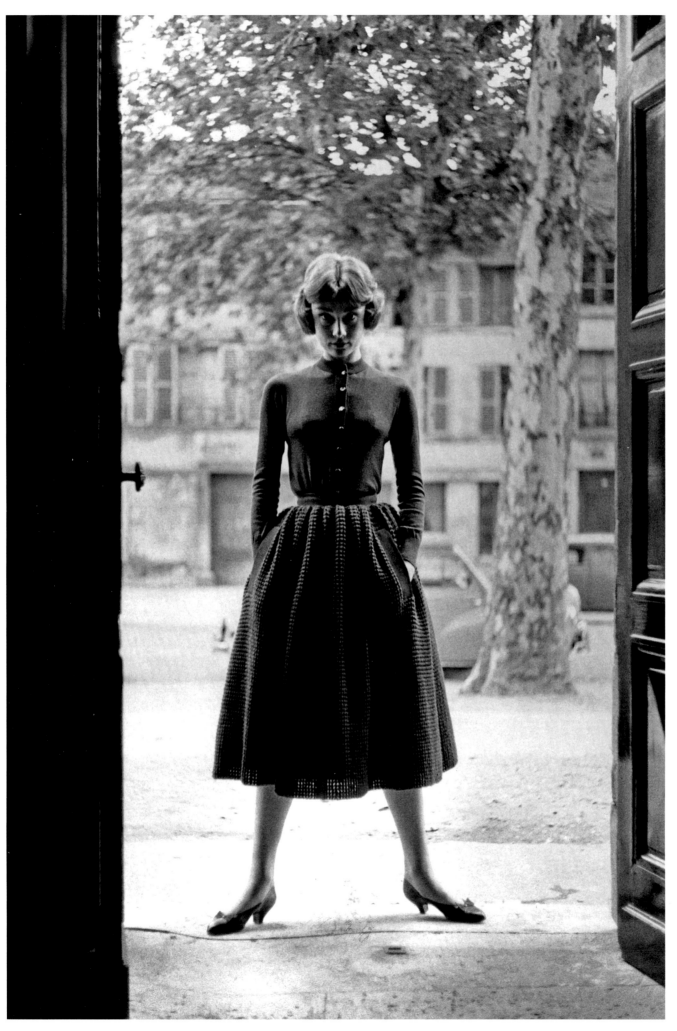

1954 / Rome, Italy / Audrey aged 24.

1957 / Paris, France / After shooting *Love in the Afternoon* with Gary Cooper, Audrey stayed alone in the French capital to rest.

1955 / Mel and Audrey pose in their garden for *Look* magazine.

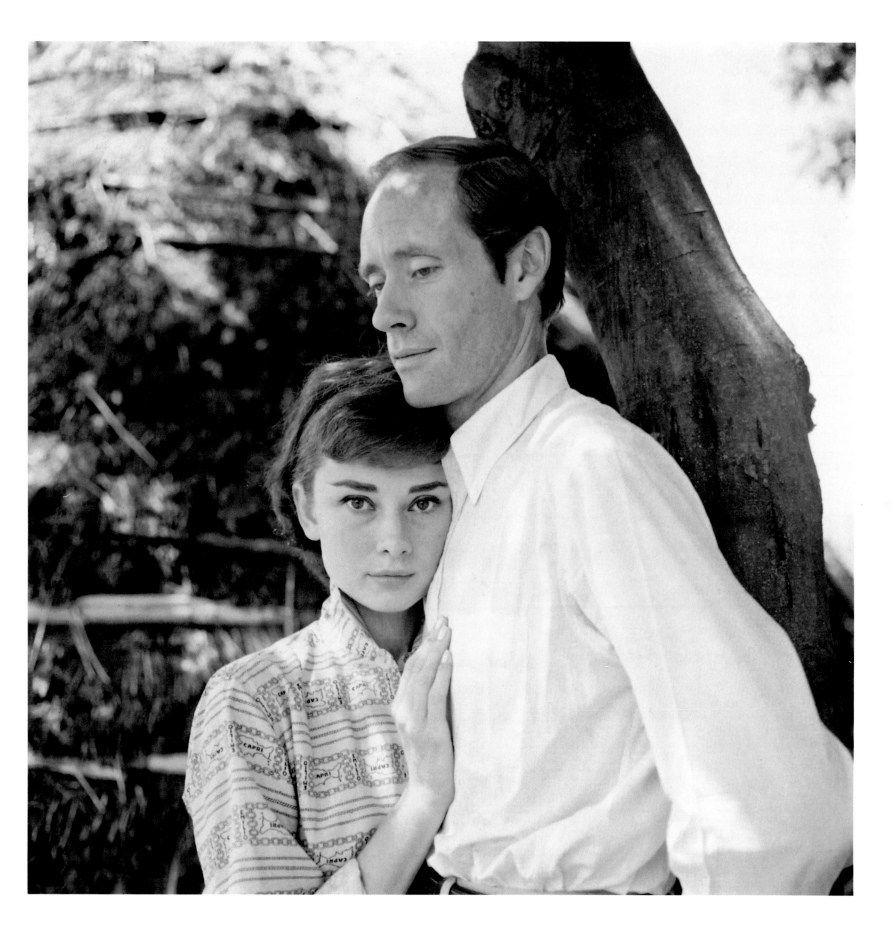

1956 / Los Angeles, CA / Mel and Audrey show off their brand new Thunderbird at the entrance to their house.

1954 / Los Angeles, CA / Audrey leaving Paramount studios after a day's filming.

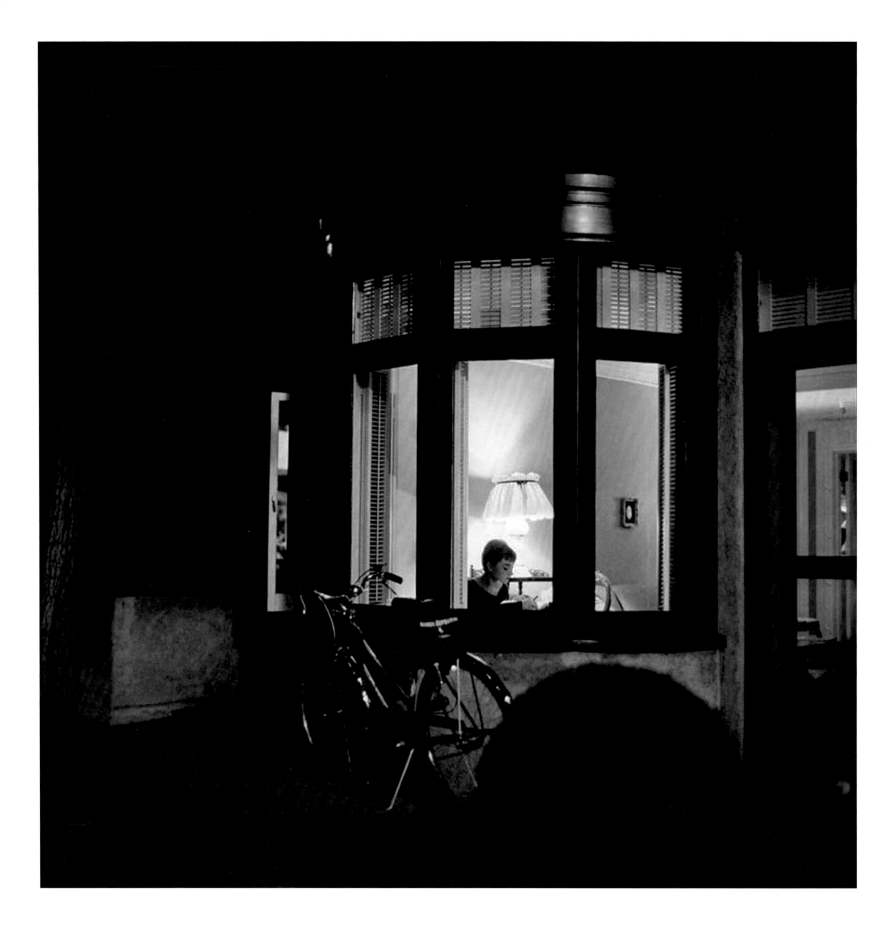

1954 / Los Angeles, CA / Audrey at home.

78

1954 / Los Angeles, CA / Audrey
with husband Mel Ferrer.

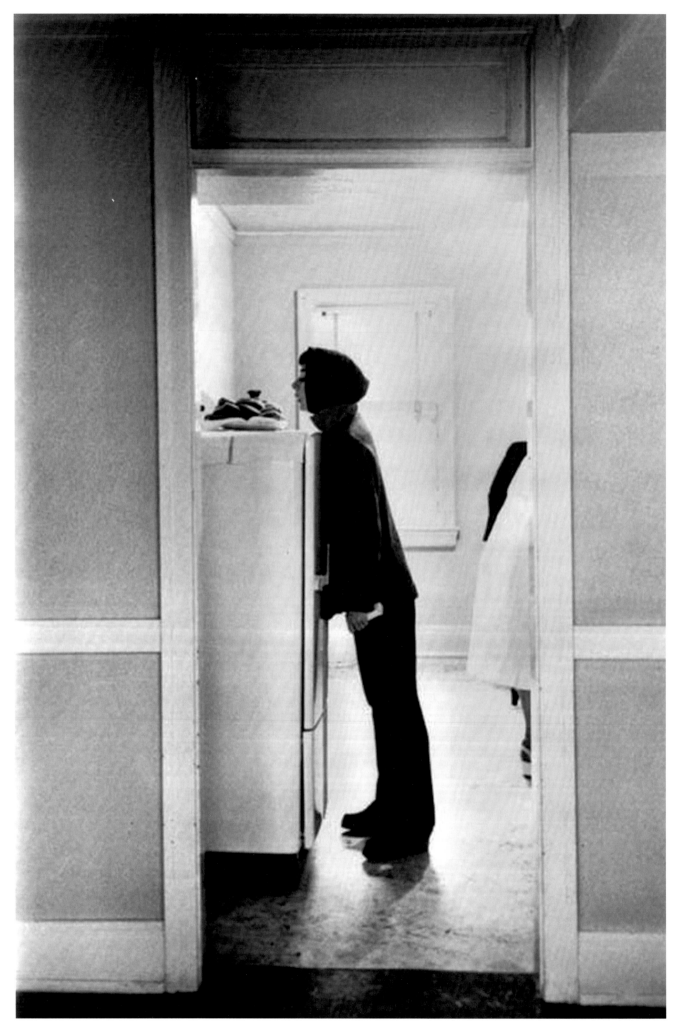

1954 / Los Angeles, CA /
Audrey in the privacy of her
apartment; looking for
'nibbles' in her kitchen.

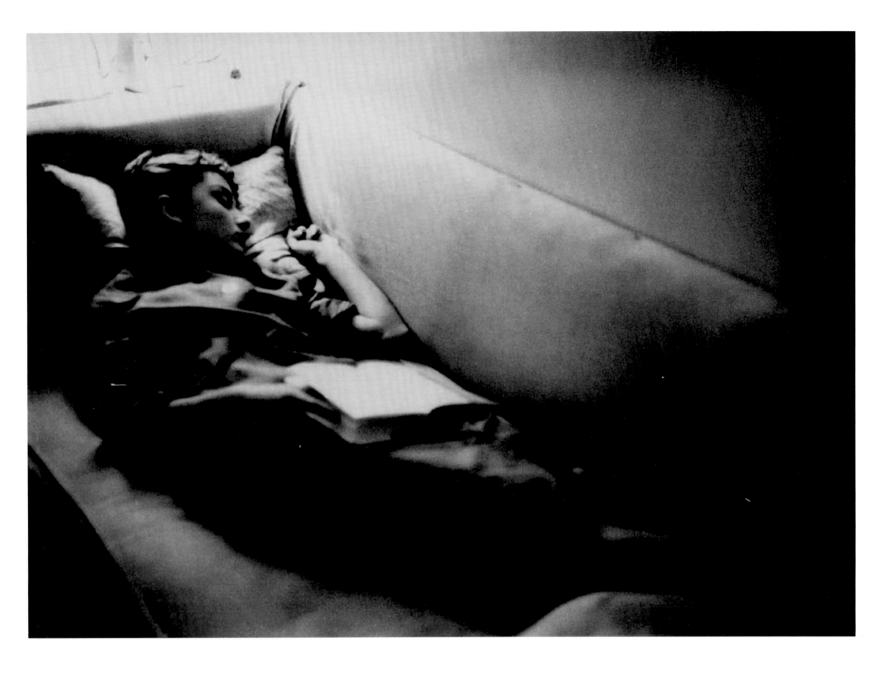

1955 / Los Angeles CA / At home. Audrey overcome by sleep after a late session re-reading a script.

« Sex appeal is something you feel deep inside. I can convey as much fully clothed, picking apples off a tree or standing in the rain. »

Audrey Hepburn

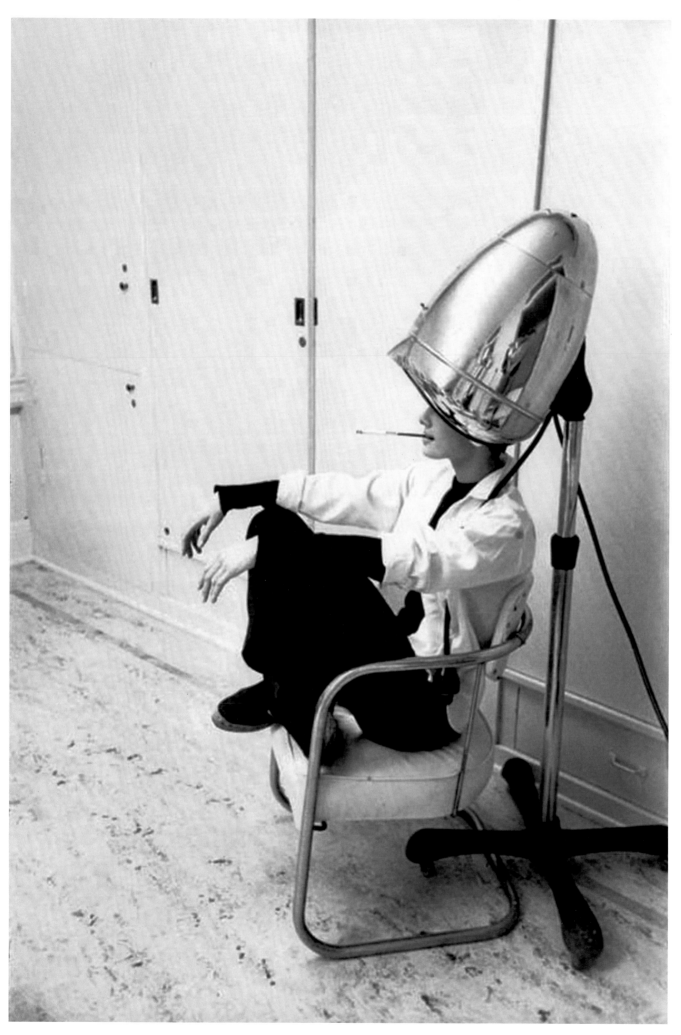

1954 / Los Angeles, CA / Break for relaxation and retouching make-up. Even with a cigarette, the star lost none of her appeal.

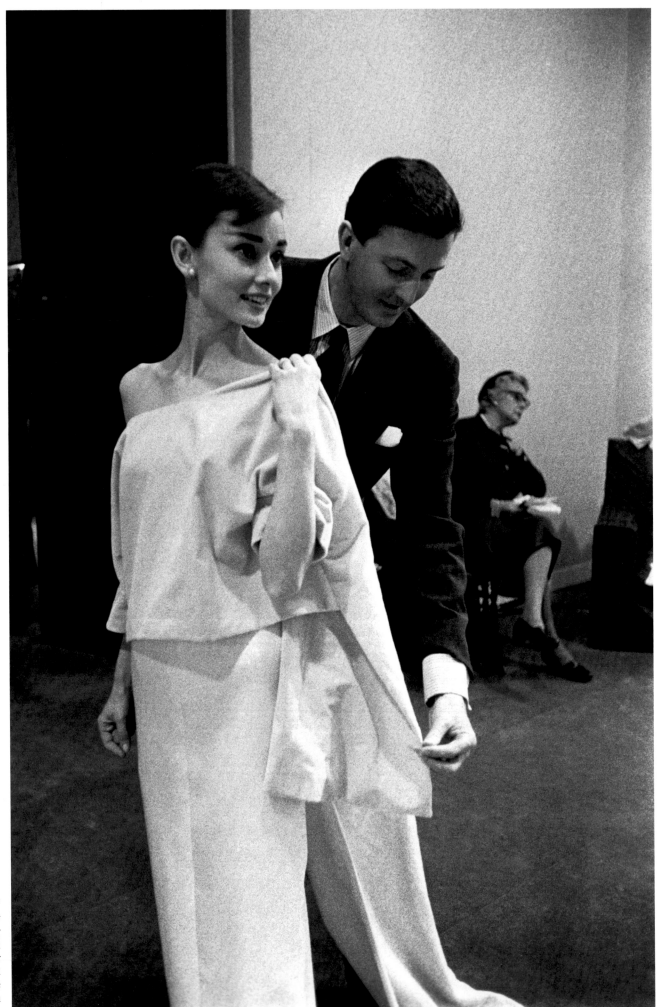

1956 / Paris, France /
Couturier Hubert de Givenchy
adjusts a gown designed for
Audrey. The star had insisted
that the producers use him for
the costumes. The two went on
to become firm and inseparable
friends until Audrey's death
in 1993.

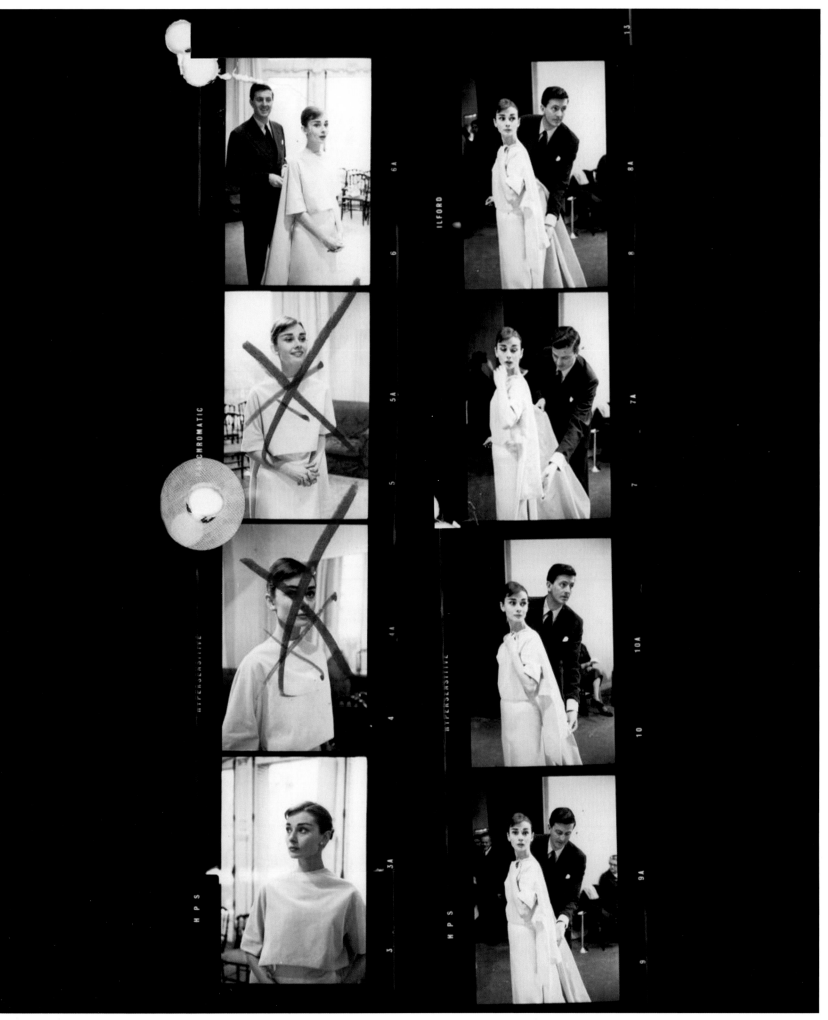

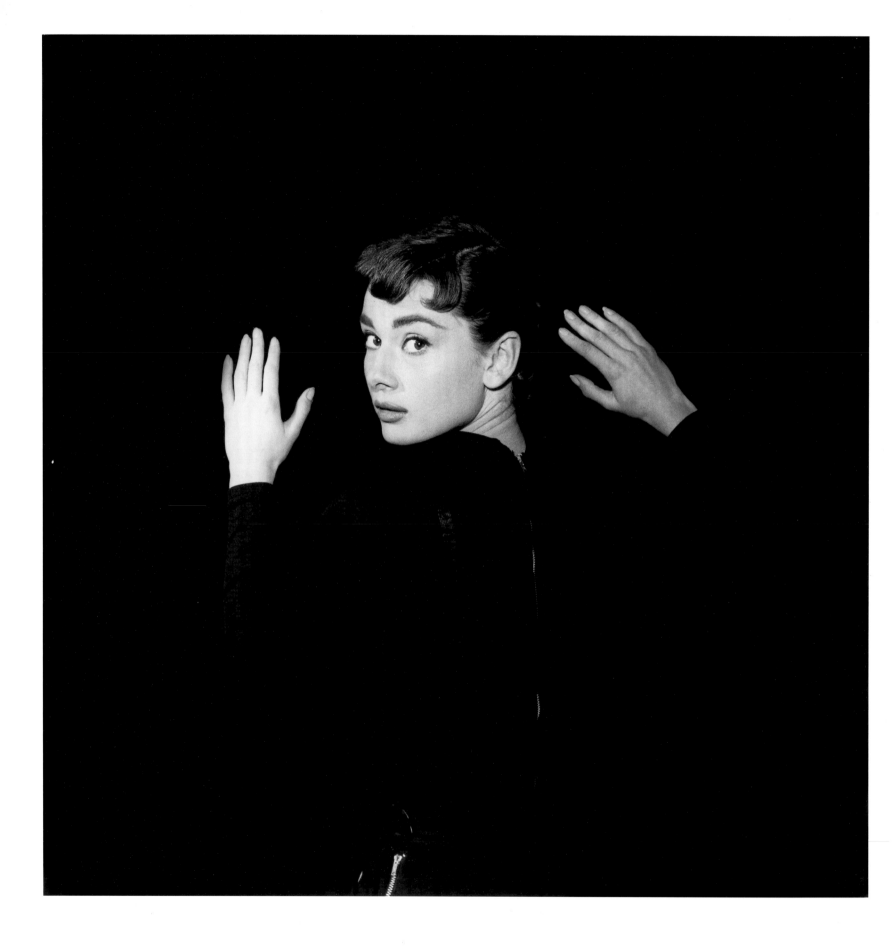

1954 / Los Angeles, CA / Portrait of Audrey at Paramount Studios.

1954 / Los Angeles, CA / Audrey on
the stages at Paramount.

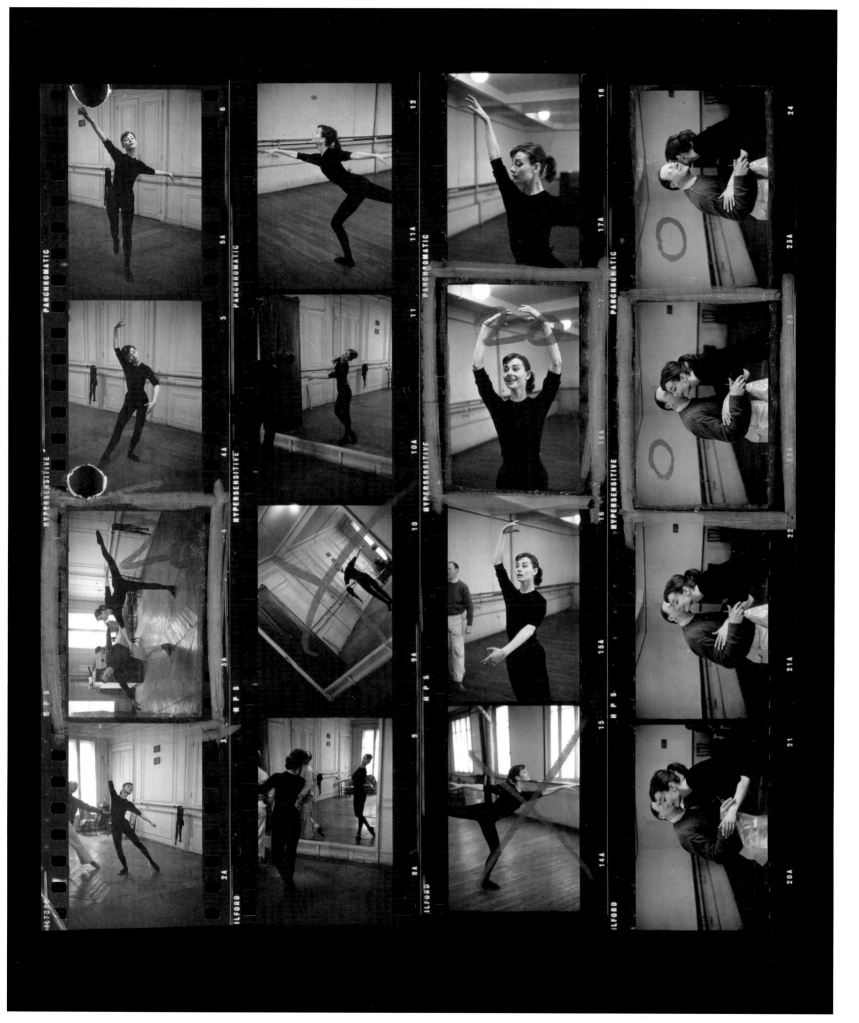

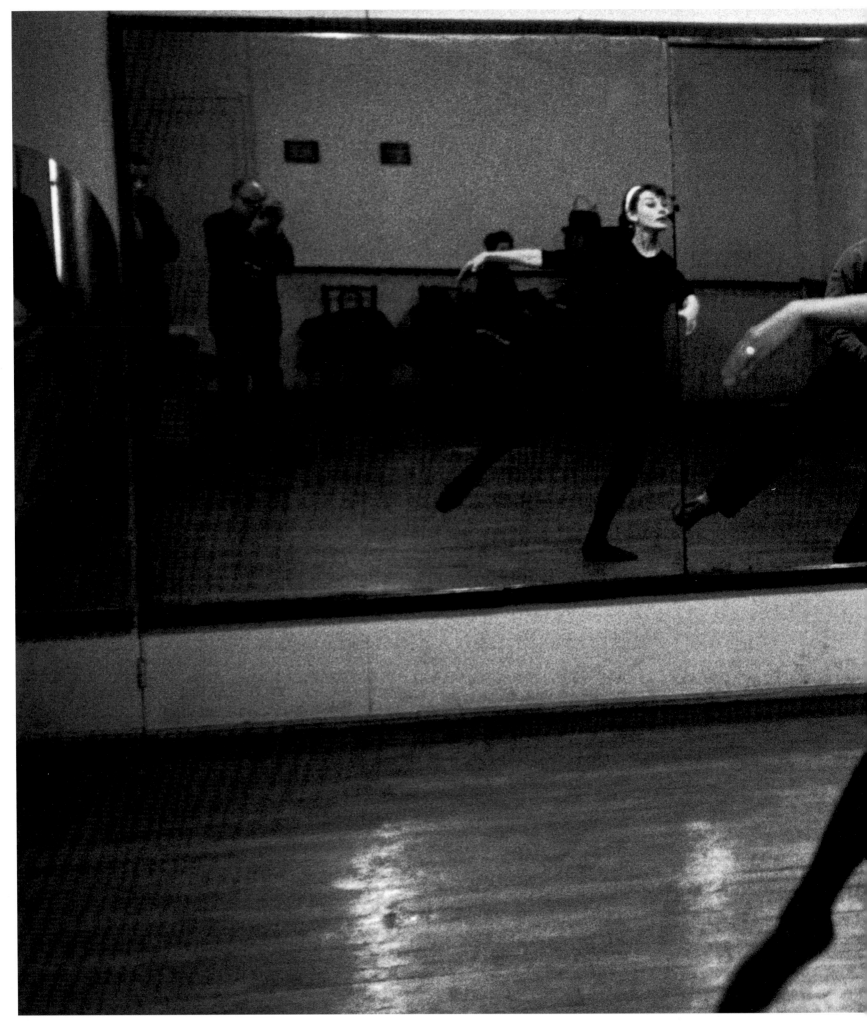

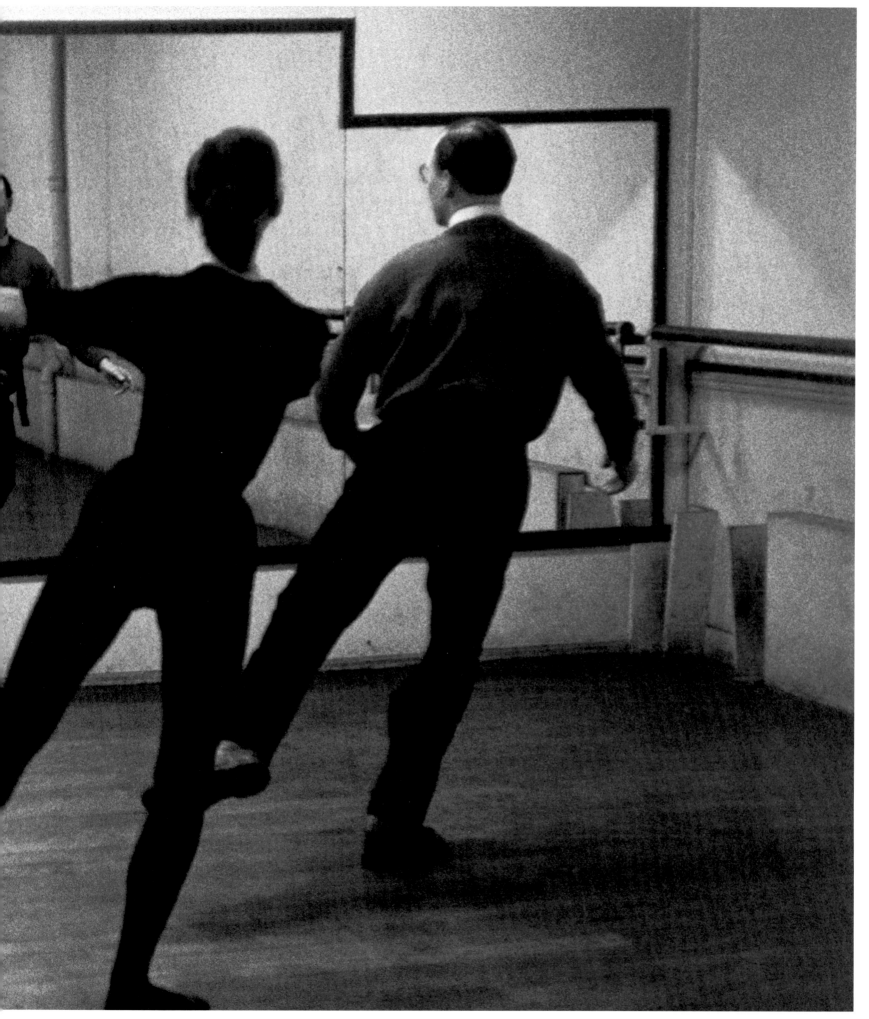

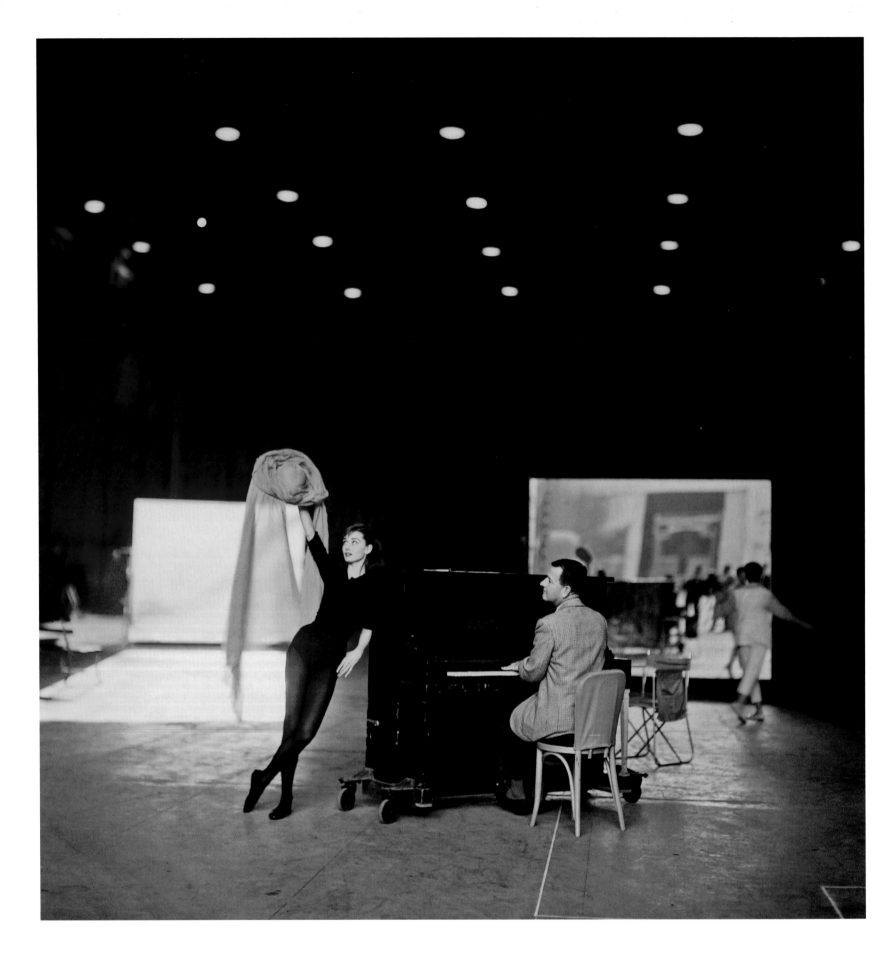

Previous pages :
1956 / Paris, France / In preparation for the shooting of *Funny Face*, Audrey submitted to a long and arduous period of dance training under Lucien Legrand, a professor at the Paris Opera.

1956 / Paris, France / Audrey rehearsing her role in *Funny Face*.

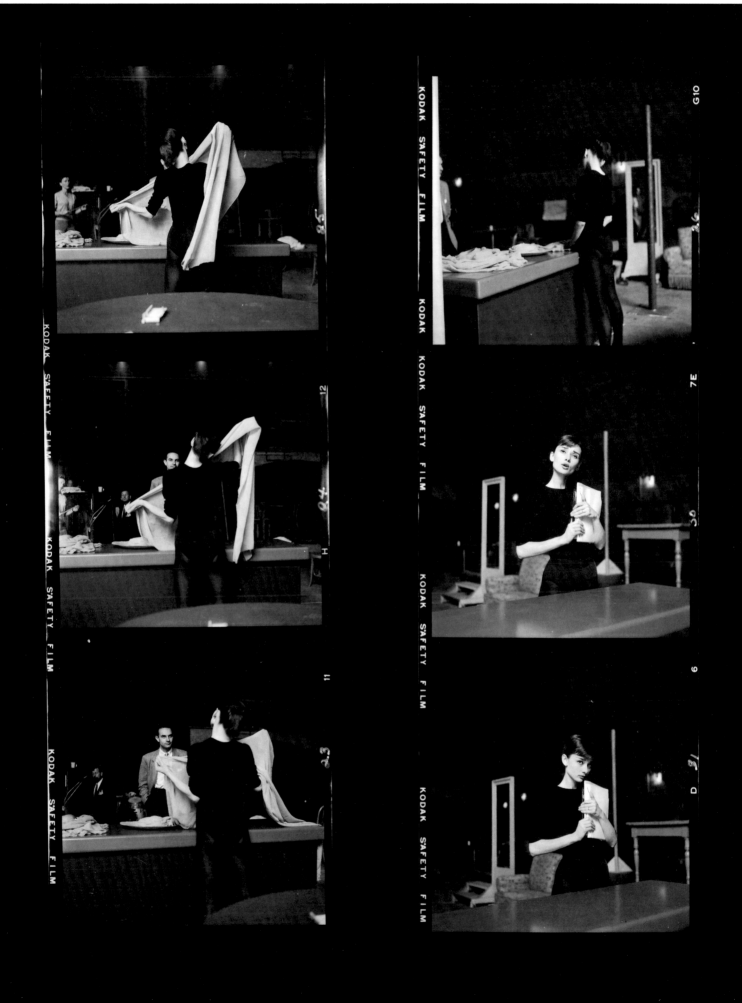

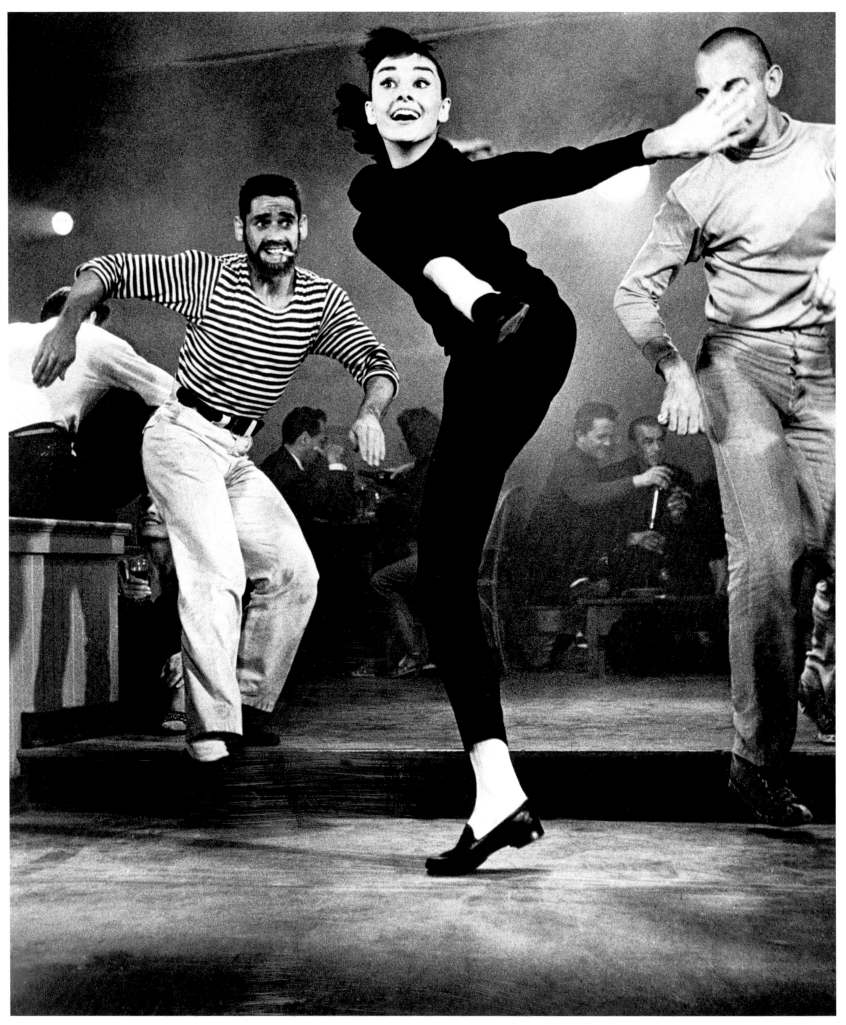

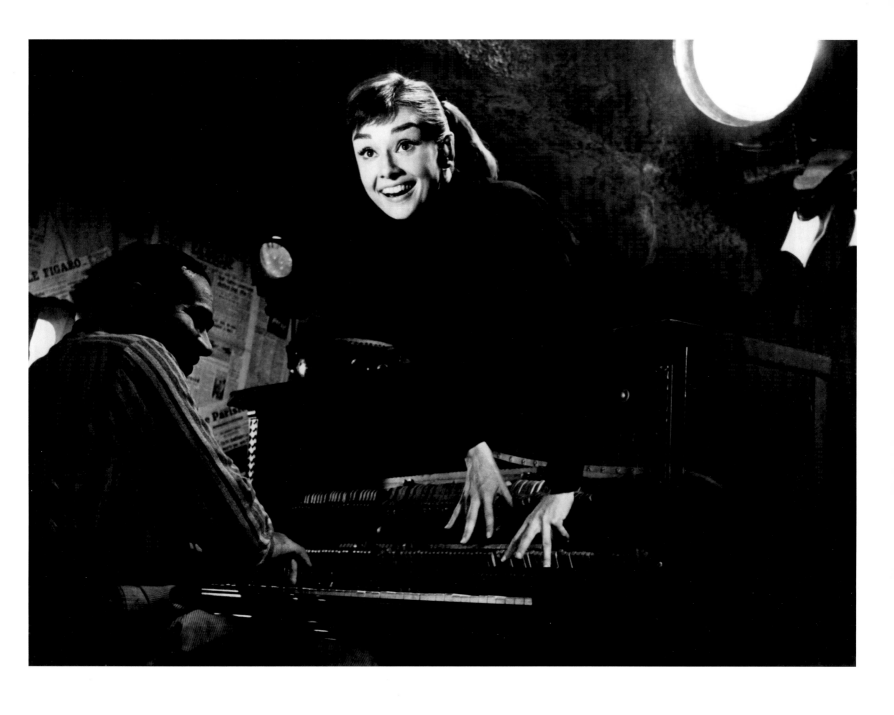

1956 / Paris, France / *Funny Face*, directed by Stanley Donen, was adapted from a 1927 Broadway show by George Gershwin.

1956 / Paris, France / In *Funny Face*, Audrey sang all the songs.

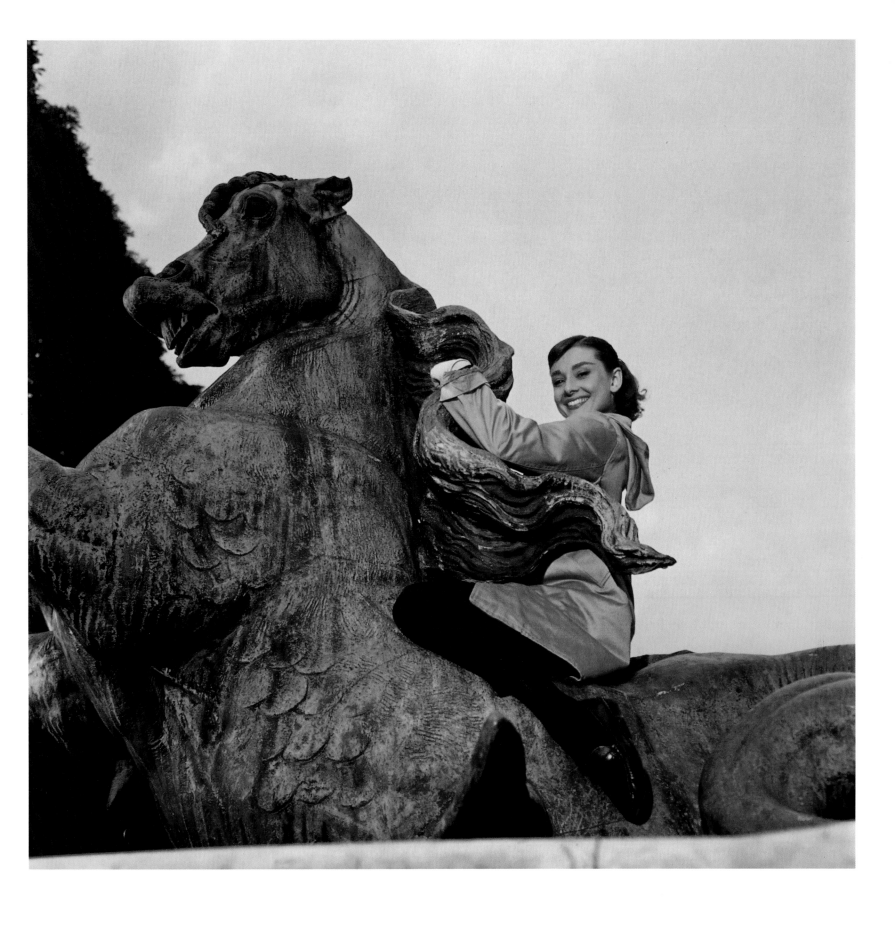

1956 / Audrey on the set of King Vidor's *War and Peace*.

« Audrey was a woman whose elegance and charm were surpassed only by her compassion for disadvantaged children. »

Elizabeth Taylor

Previous pages :
1957 / Audrey enjoying a day's riding with her husband Mel Ferrer.

1959 / Audrey, aged 29, during the making of *The Nun's Story*.

118

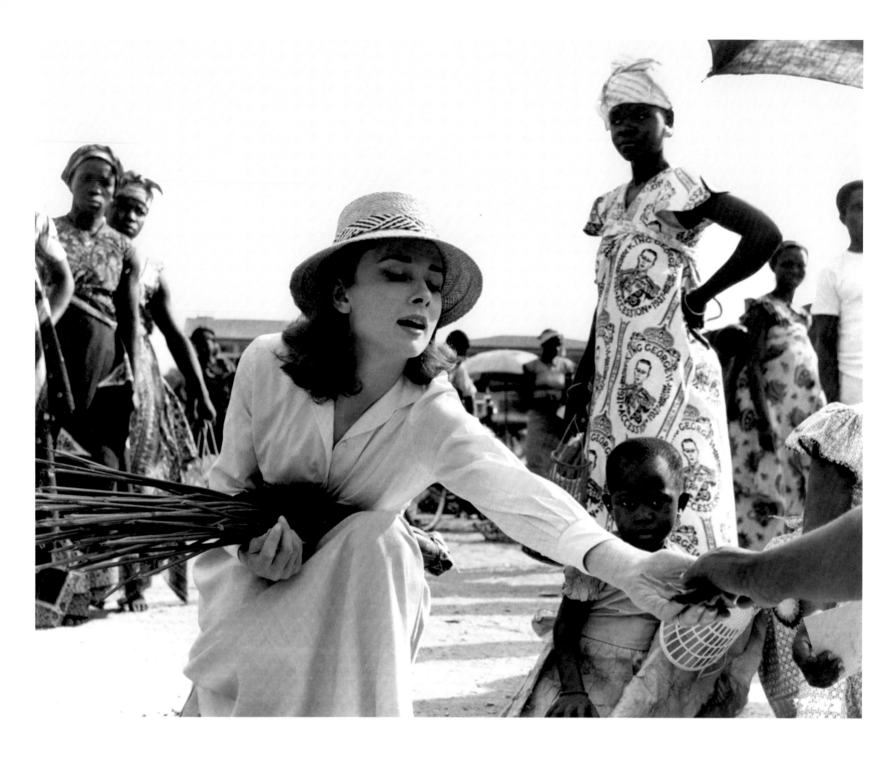

1959 / Congo / In *The Nun's Story*, Audrey plays a Belgian nun who is sent to Africa in the 1930s as a nurse but returns to aid the Resistance against the Nazis. By a historical coincidence, a few months after the film was shot, the Congo rose against Belgian colonial rule.

1959 / Congo / Audrey's first encounter with Africa was legendary.

1959 / Durango, Mexico /
Audrey, then 30, during the
production of John Huston's
The Unforgiven.

1959 / Durango, Mexico / Rest day during the shooting of *The Unforgiven*.

123

« Success is like reaching an important birthday and finding you're exactly the same. »

Audrey Hepburn

1960 / New York City / Audrey at thirty-one.

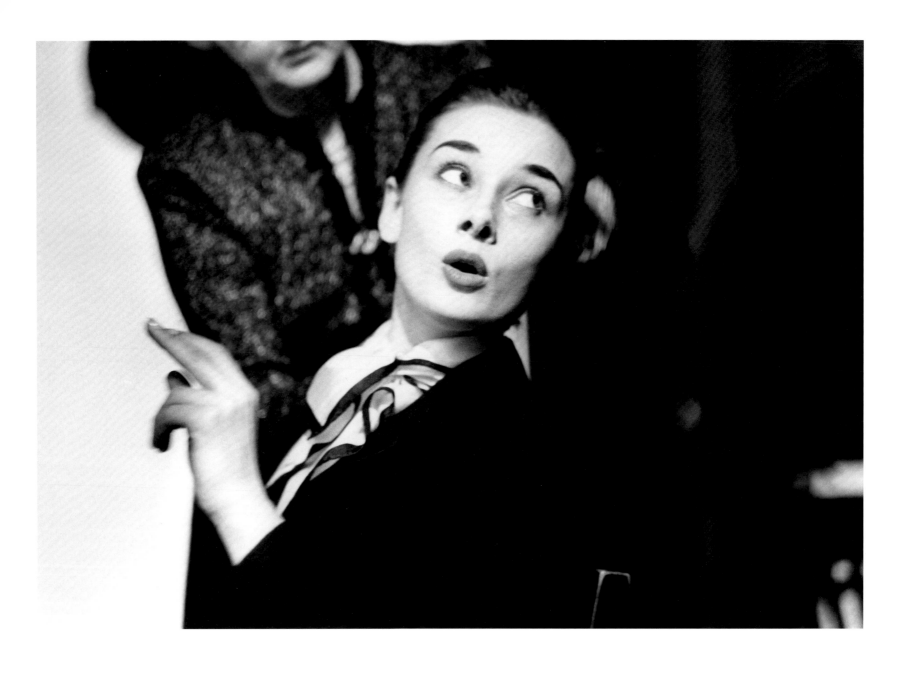

1963 / Make-up session prior to shooting of scene from *Charade* (dir. Stanley Donen).

1961 / Paris, France / Designer Hubert de Givenchy with Audrey at a fitting session.

« My look is attainable. Women can look like Audrey Hepburn by flipping out their hair, buying the large sunglasses, and the little sleeveless dresses. »

Audrey Hepburn

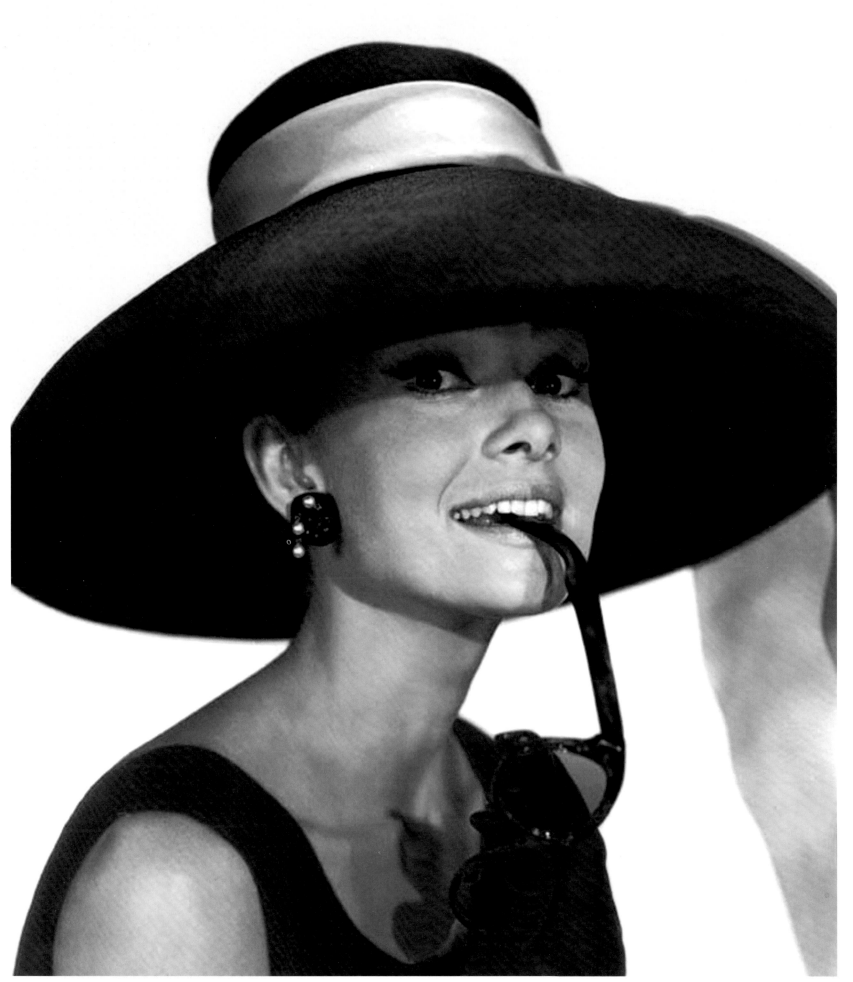

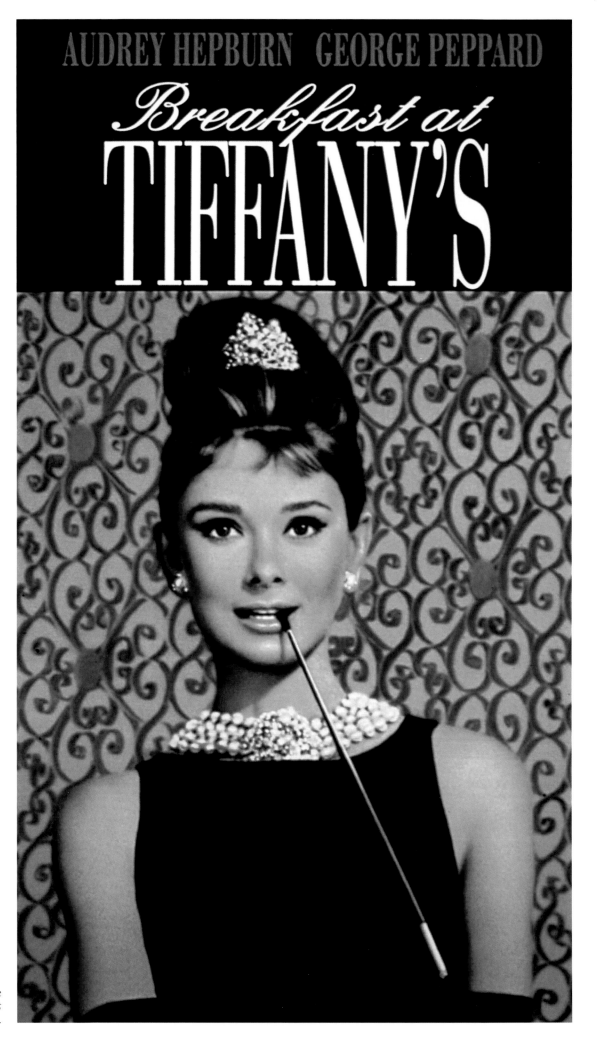

AUDREY HEPBURN GEORGE PEPPARD

Breakfast at TIFFANY'S

1961 / Poster for Blake Edward's *Breakfast at Tiffany's.*

1961 / New York City / The role of Holly in *Breakfast at Tiffany's* was originally intended for Marilyn Monroe, but Paramount forced the director to substitute Audrey.

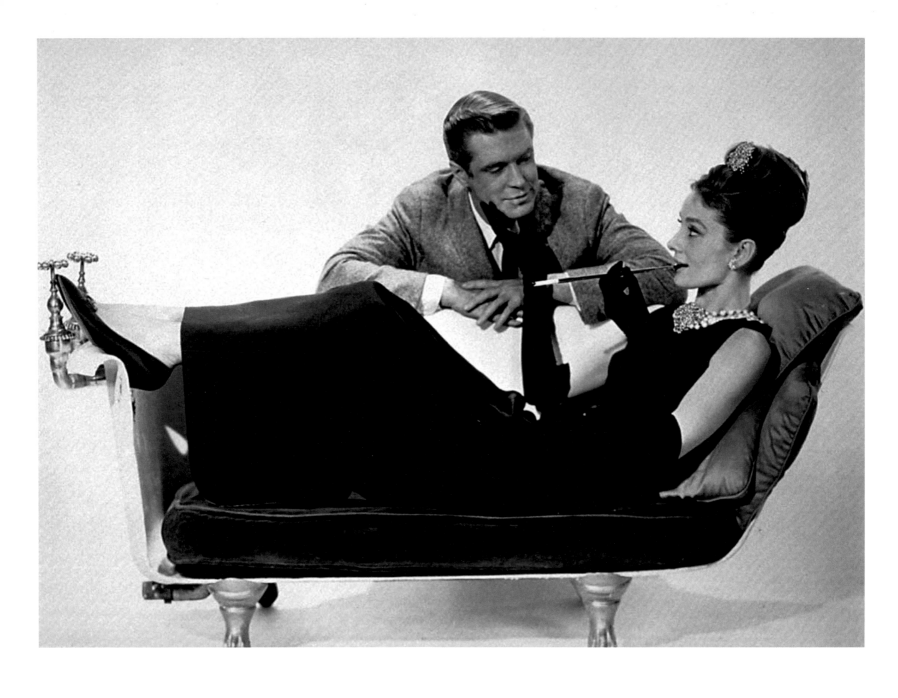

1961 / Los Angeles, CA / Audrey with George Peppard on the set of *Breakfast at Tiffany's*.

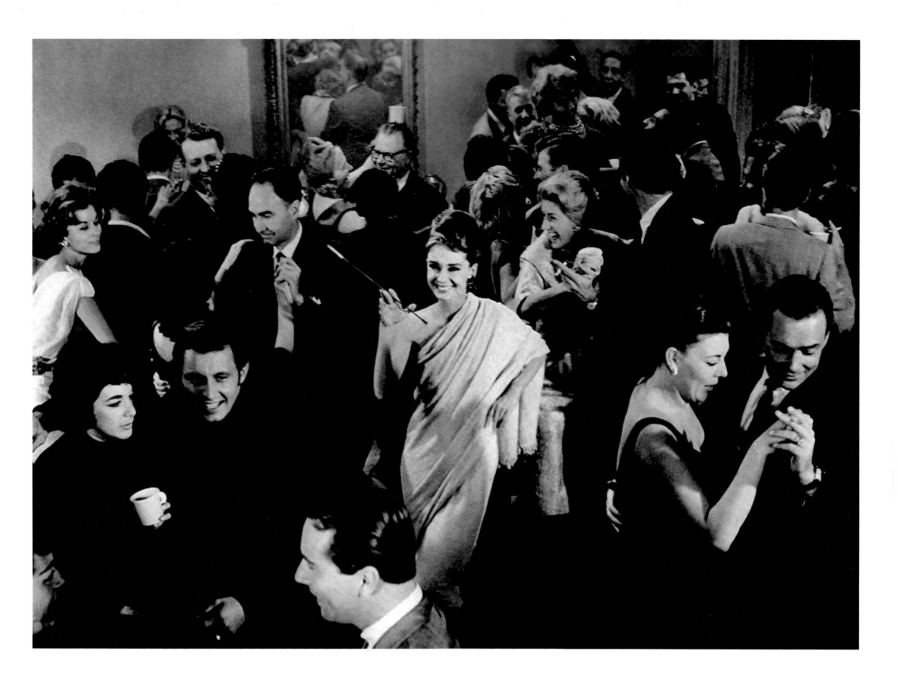

1961 / Los Angeles, CA / Audrey during shooting for *Breakfast at Tiffany's*, directed by Blake Edwards.

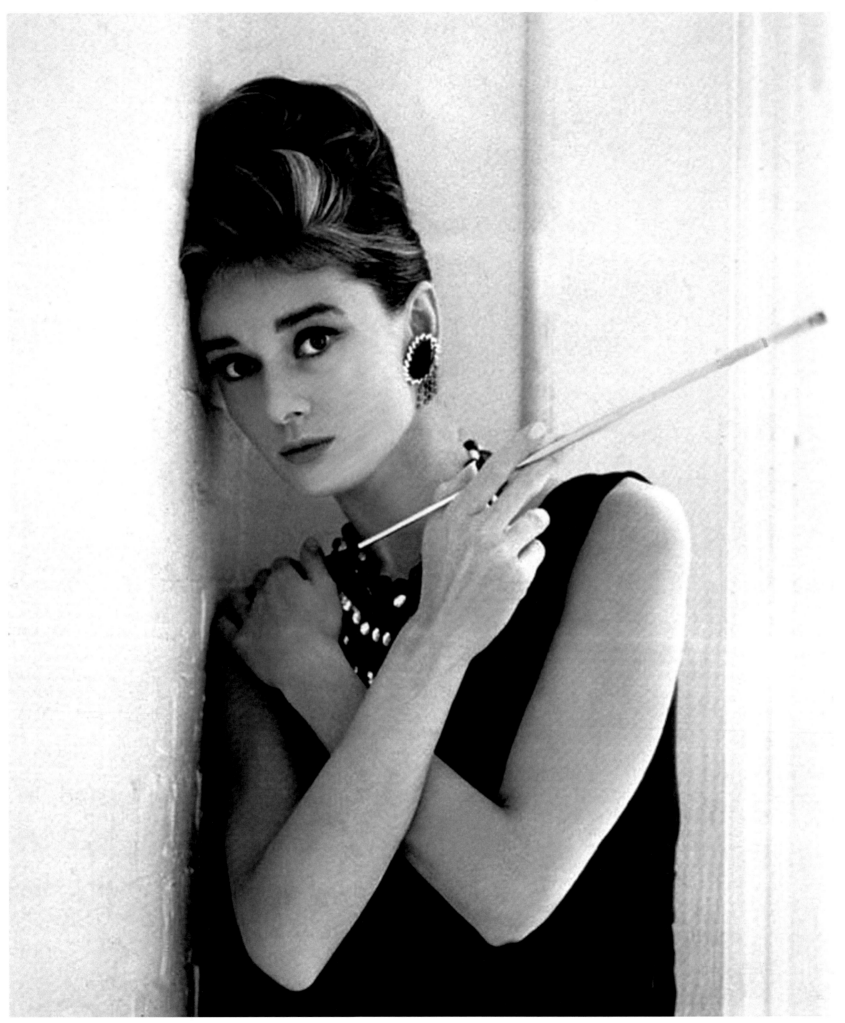

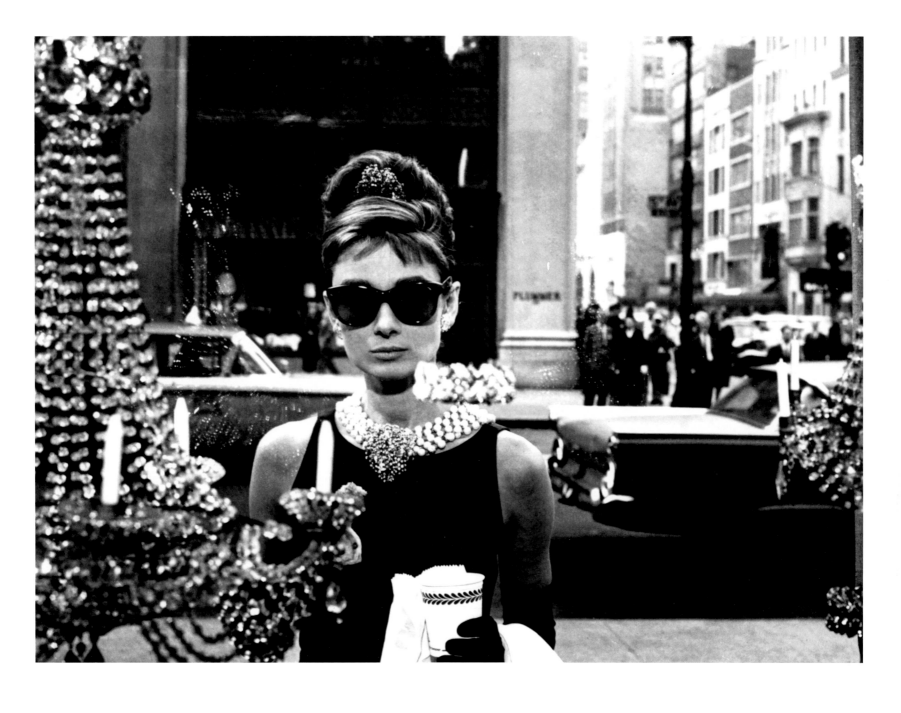

1961 / New York City / *Breakfast at Tiffany's* brought Audrey her fourth Oscar nomination.

1961 / New York City / For the first time in its 200-year history, the famous jewellery firm of Tiffany's (founded 1837) opened its doors on a Sunday for shooting of the film's iconic scene.

« I have accomplished far more than I had ever hoped. Most of the time it happened to me without my ever seeking it. »

Audrey Hepburn

1955 / Italy / Portrait by Philippe Halsman for a cover of *Life* magazine.

150

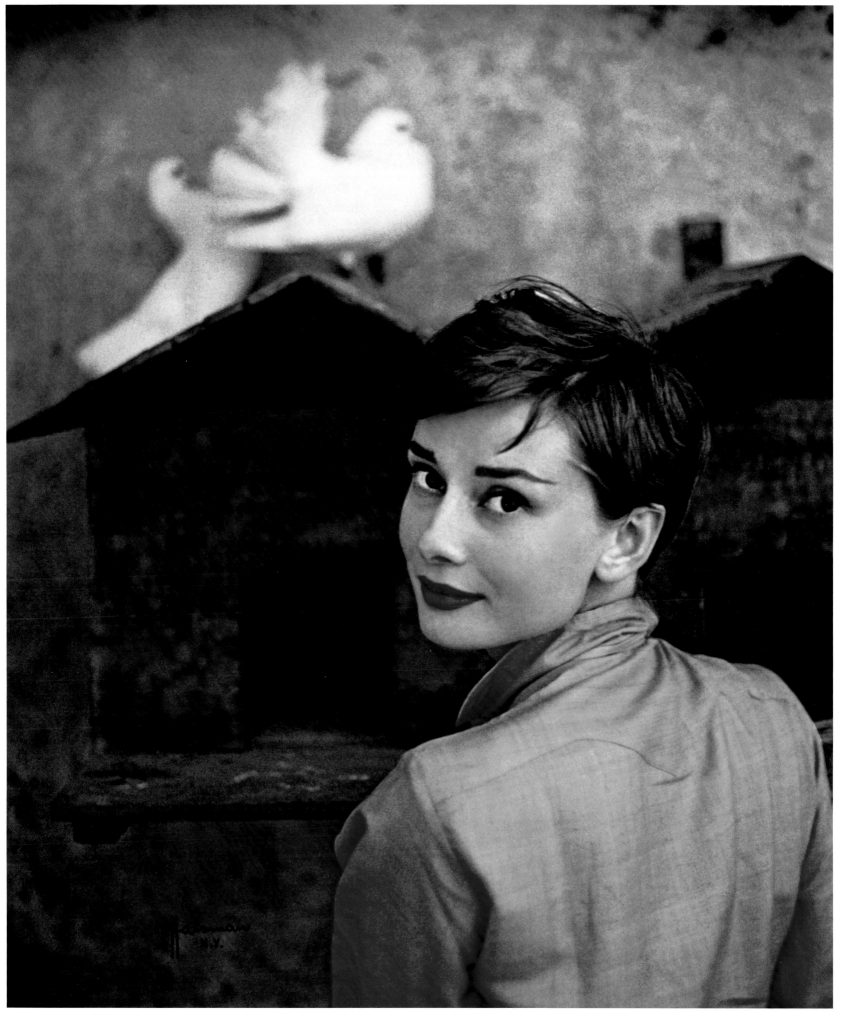

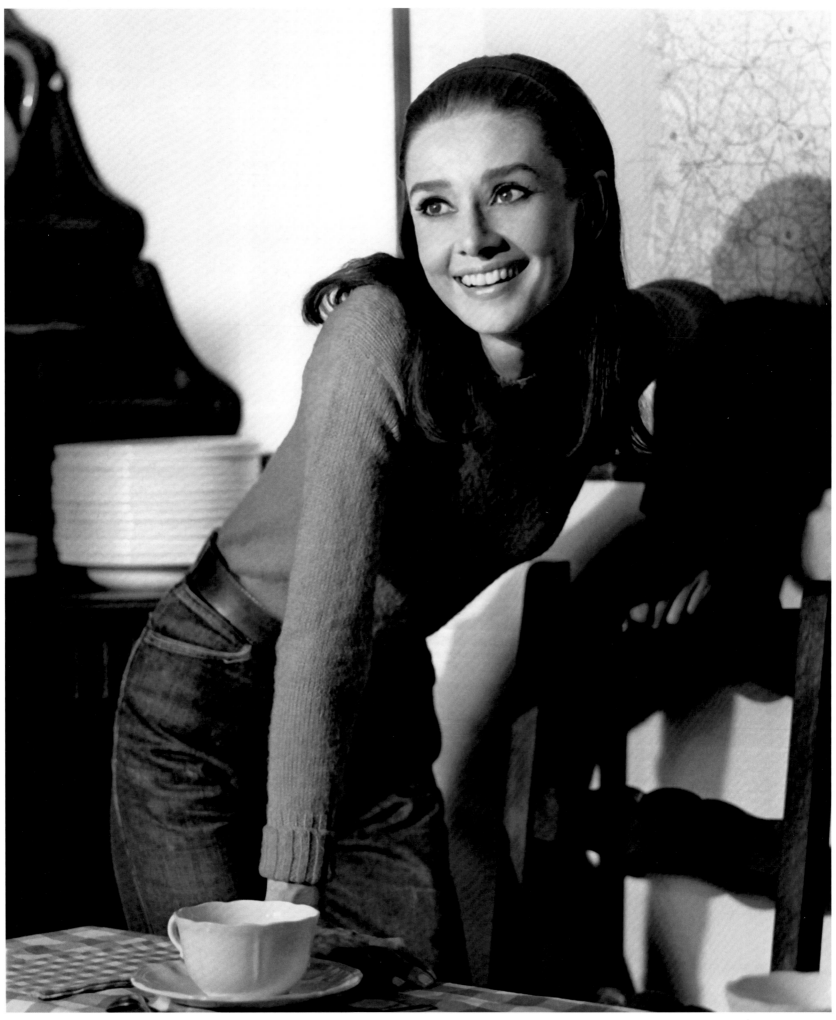

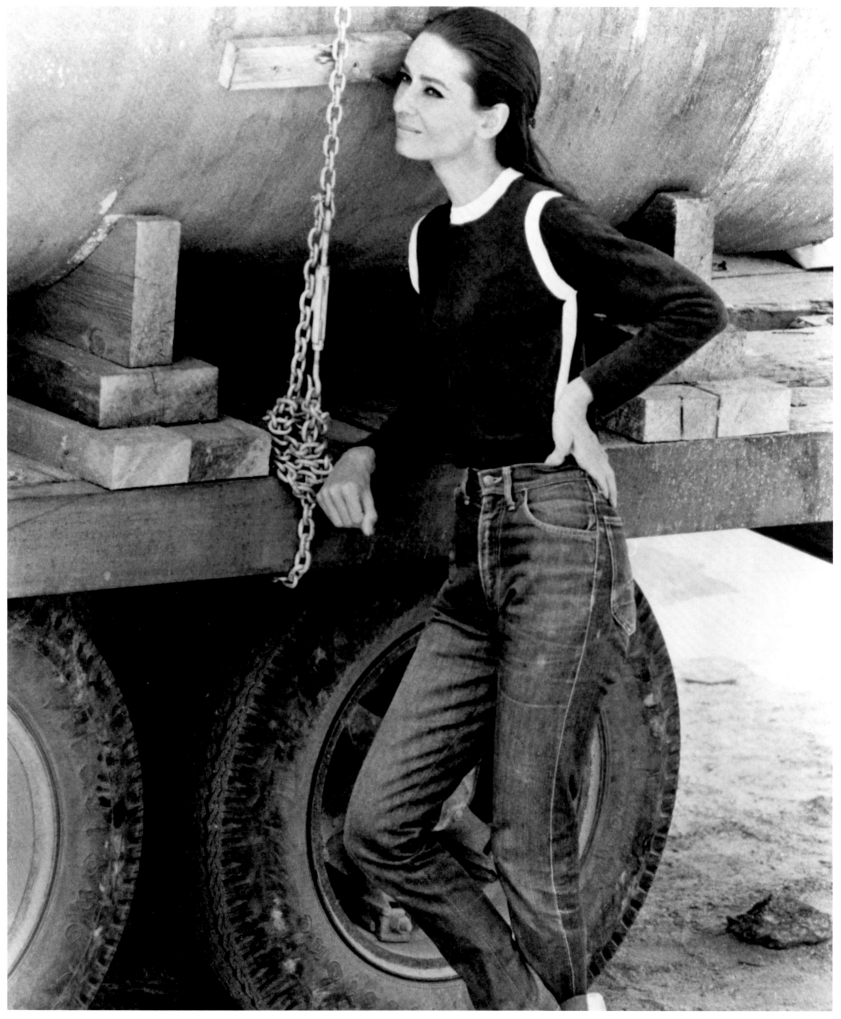

« I'm not stacked like Sophia Lauren or Gina Lollobrigida, but I don't need a bedroom to prove my womanliness. »

Audrey Hepburn

Previous pages :
1967 / Audrey by the set of *Wait Until Dark*, directed by Terence Young. She was now 38.

154

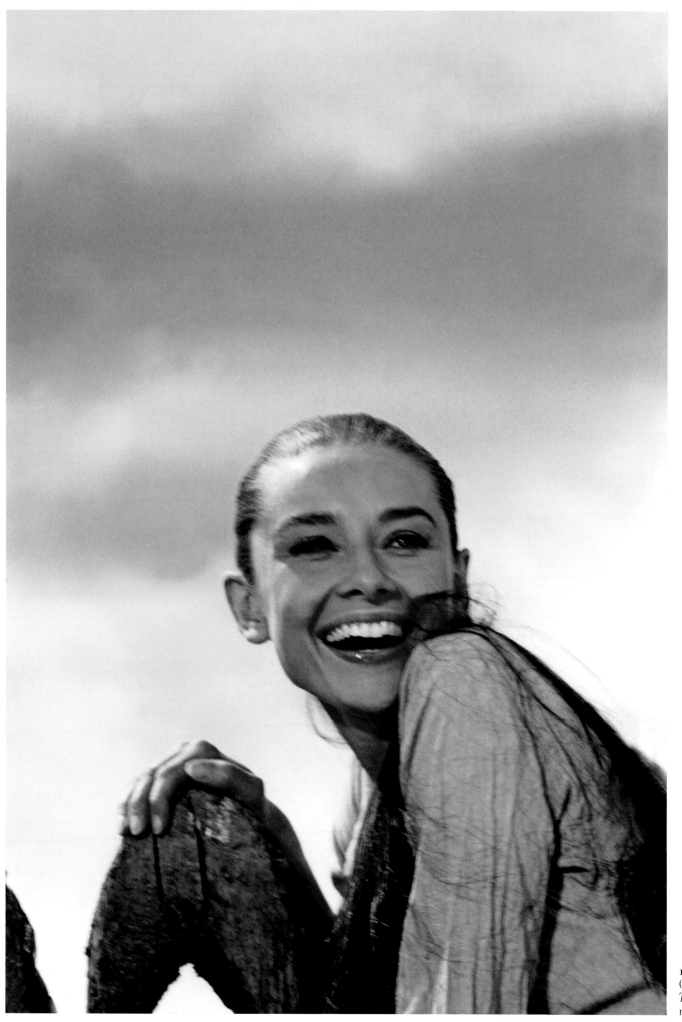

1959 / Durango, Mexico /
On the set of John Huston's
The Unforgiven. Audrey was
now thirty.

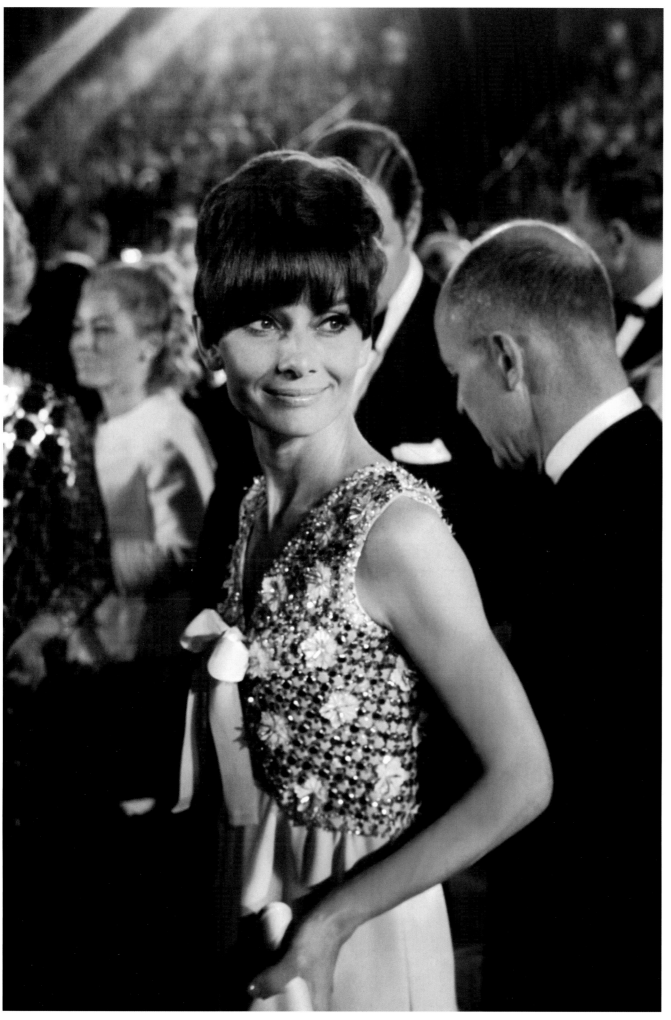

1964 / Los Angeles, CA / Audrey
at the Oscar ceremony.

« The best thing to hold onto in life is each other.»

Audrey Hepburn

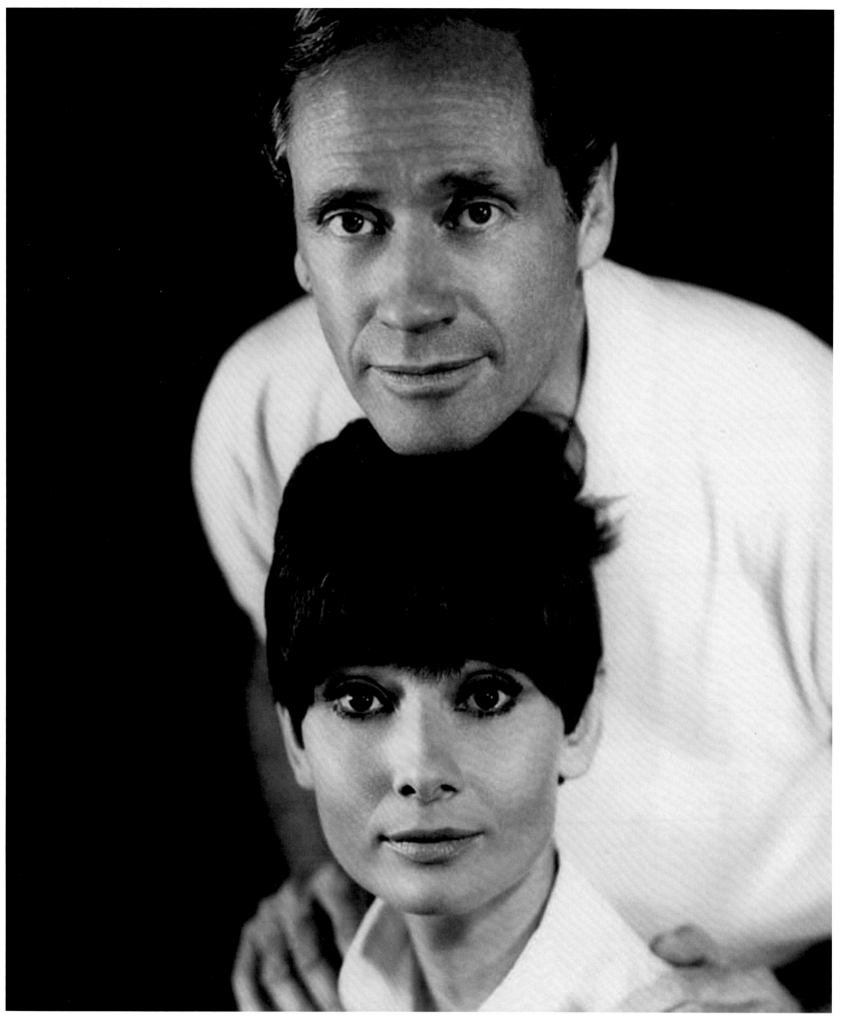

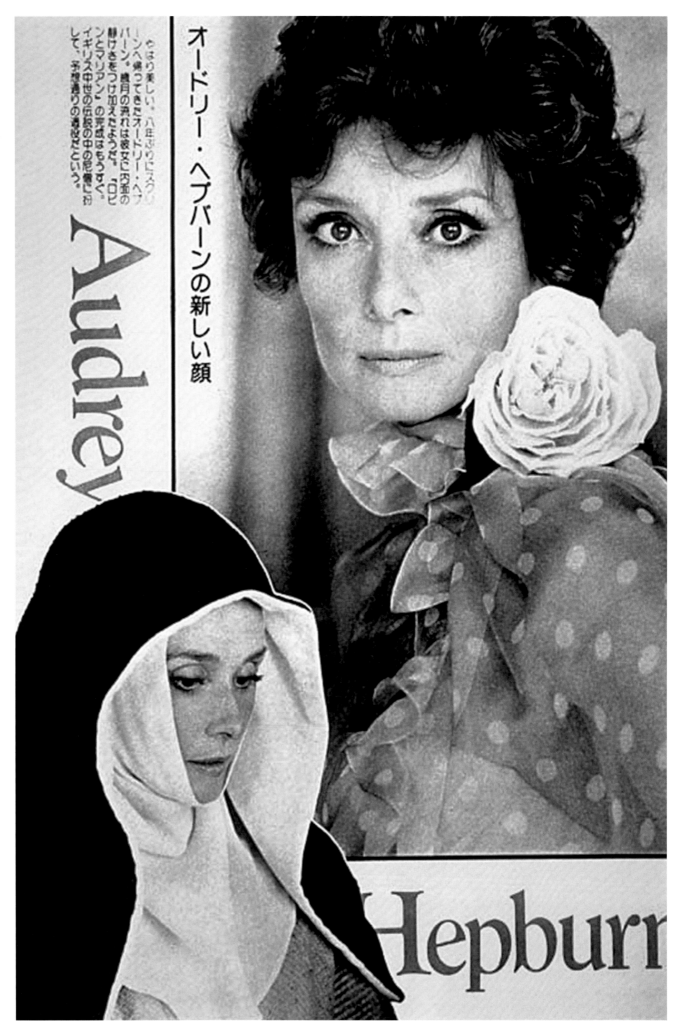

やはり美しい。八年ぶりにスクリーンへ帰ってきたオードリー・ヘプバーン。歳月の流れは彼女に内面の静けさをつけ加えたようだ。『ロビンとマリアン』の完成はもうすぐ。イギリス中世の伝説の中の尼僧に扮して、予想通りの適役だという。

Audrey

Hepburn

1976 / Poster for *Robin and Marian* (dir. Richard Lester), the movie marking Audrey's big return to the screen after nine years' absence. Playing opposite her was Sean Connery.

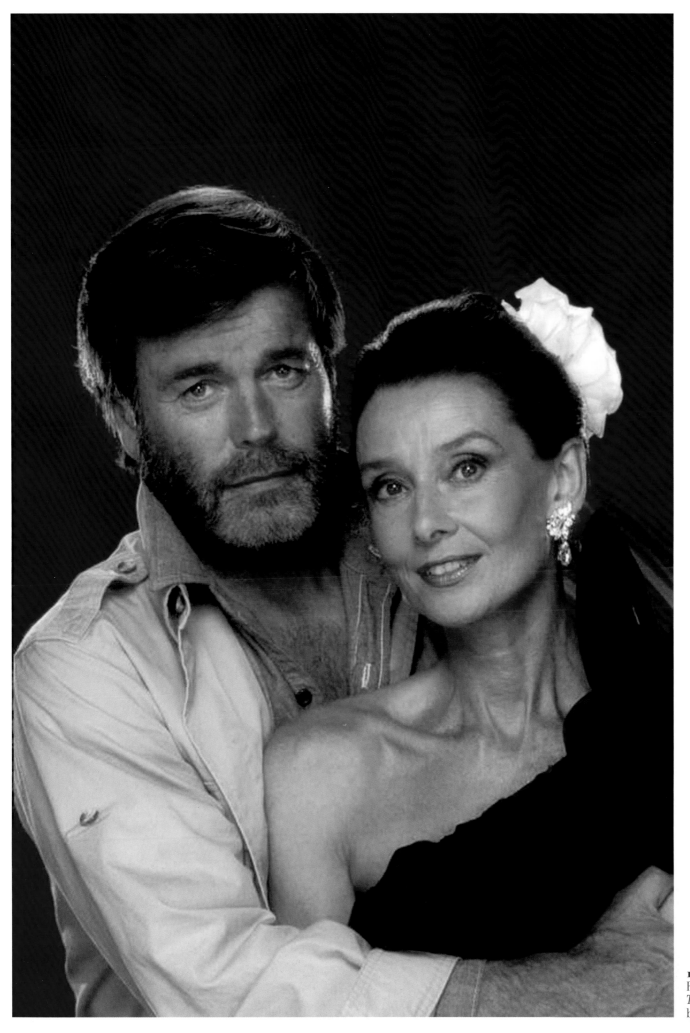

1986 / Audrey starred with
Richard Wagner in *Love Among
Thieves*, an ABC telefilm directed
by Roger Young.

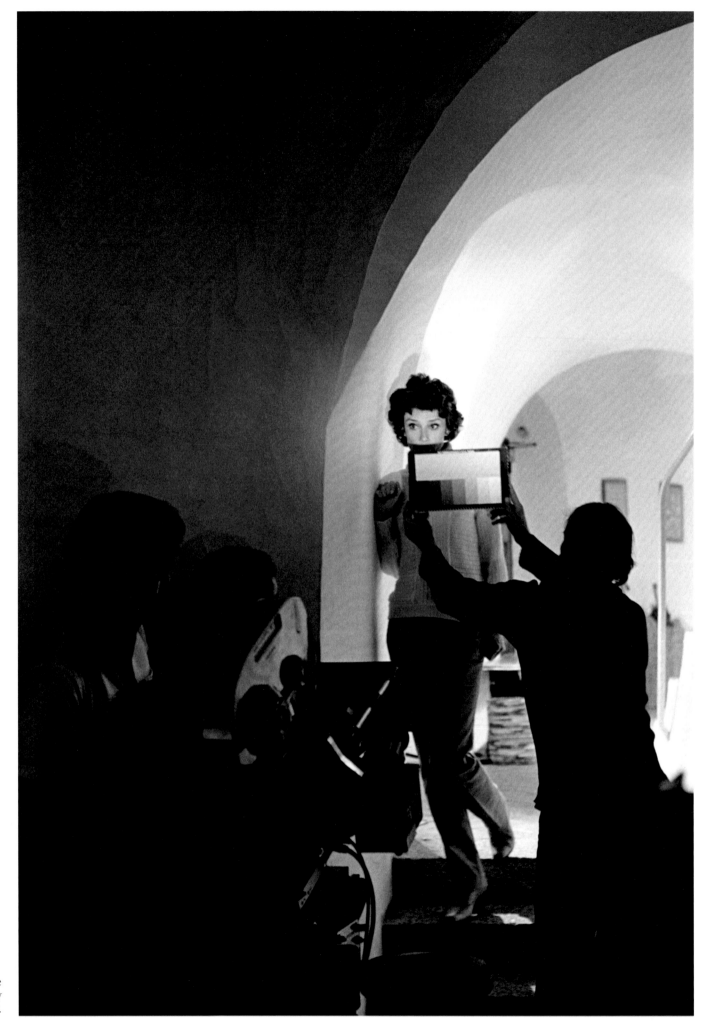

1979 / Sardinia, Italy / On the set of *Bloodline*, directed by Terence Young.

174

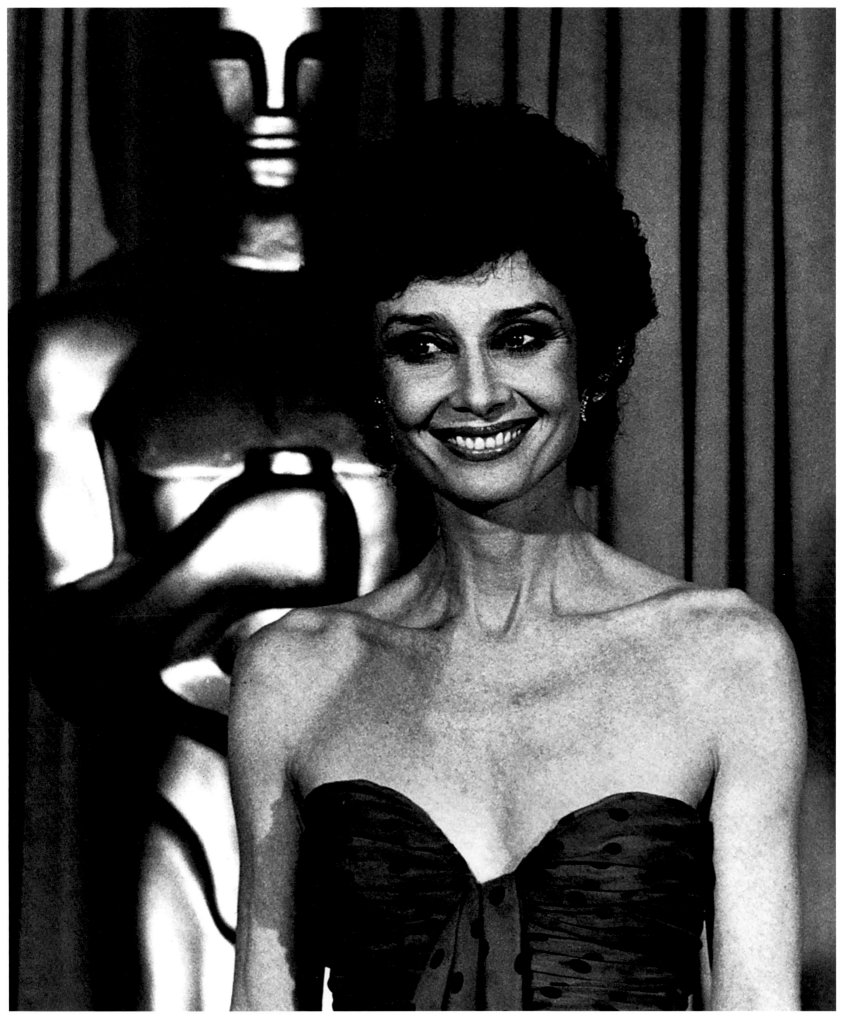

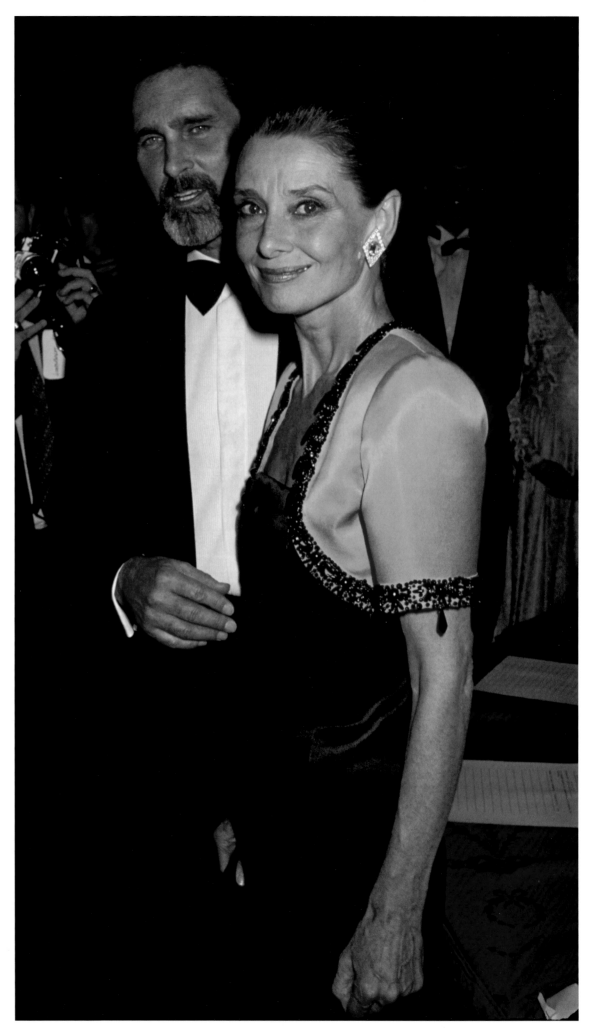

1983 / Los Angeles, CA / Audrey and Robert Wolders, her partner since 1981.

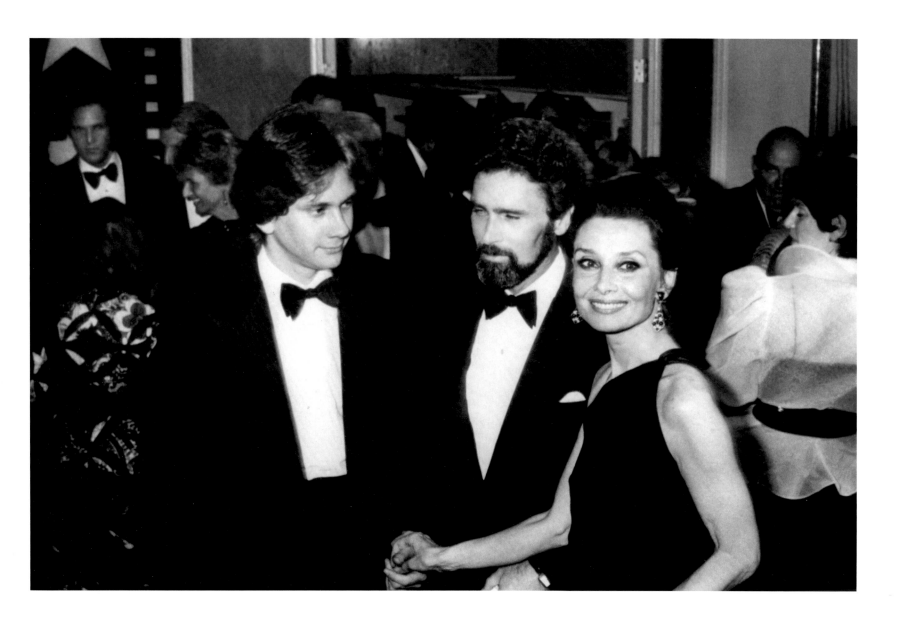

April 1981 / Los Angeles, CA / Audrey Hepburn with Robert Wolders and her son Sean Ferrer at a gala evening given by the American Film Institute.

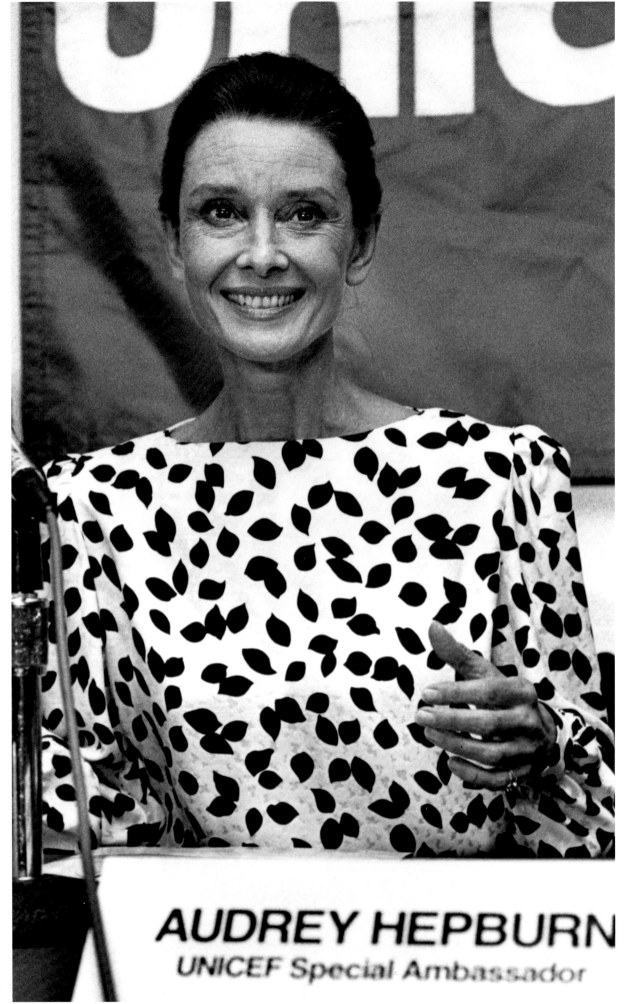

April 1989 / Washington DC / Back from Africa, Audrey testifies before the House Select Subcommittee on Hunger, declaring: 'I have been given the privilege of speaking for children who cannot speak for themselves, and my task is an easy one because children have no political enemies. To save a child is a blessing: to save a million is a God-given opportunity.'

AUDREY HEPBURN
UNICEF Special Ambassador

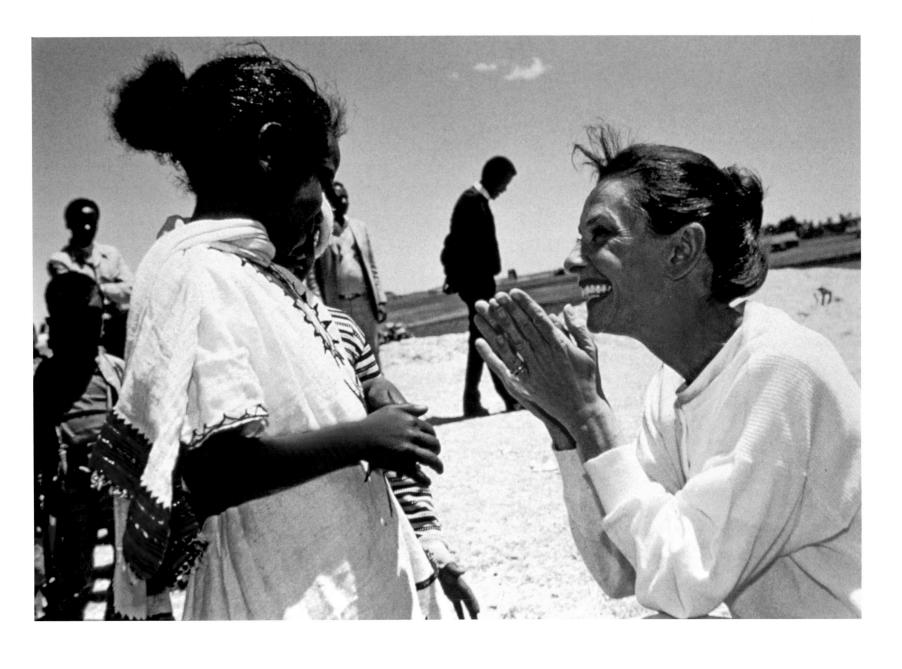

March 1988 / Ethiopia / Audrey, visiting Ethiopia and Tigre in her role as ambassadress for UNICEF, came face to face with the horrors of poverty. She was haunted ever afterwards by images of children emaciated by famine. On returning to London, she concentrated her efforts, arranging press conferences to focus the spotlight on the region's problems.

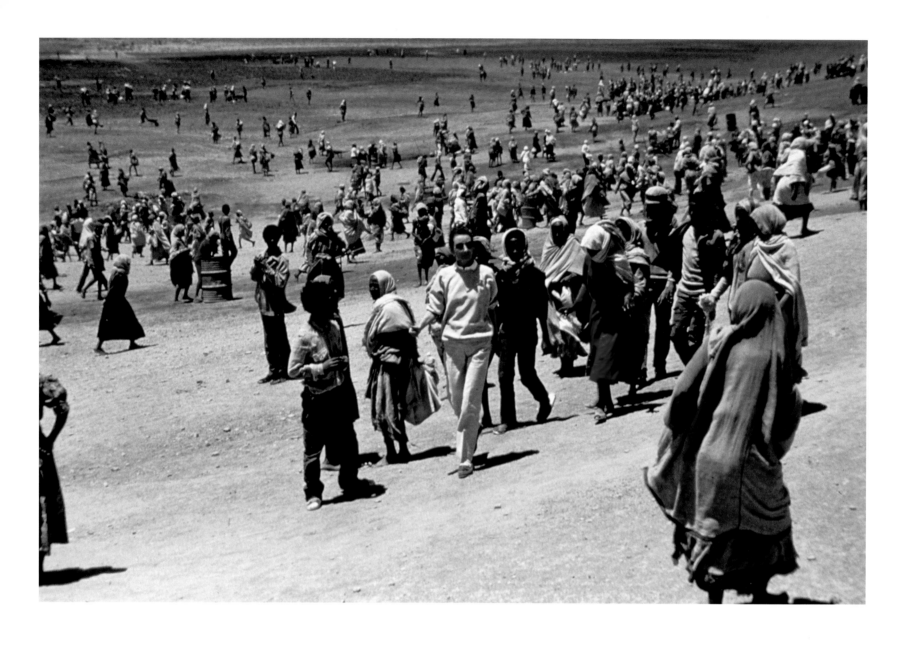

March 1988 / Audrey visiting refugee camps in Ethiopia.

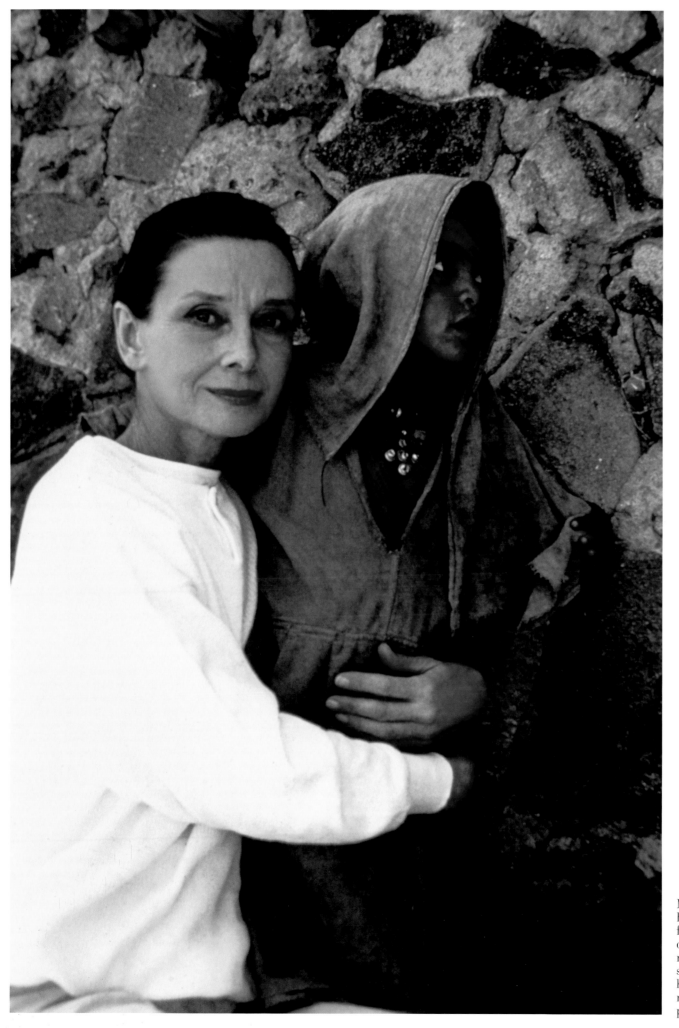

March 1988 / Audrey visits Ethiopia in her role as ambassadress for UNICEF. Meeting children dying of starvation would leave a lasting mark on the star, giving her sleepless nights. She was to invest all her energy into her humanitarian mission to save as many lives as possible in Africa.

181

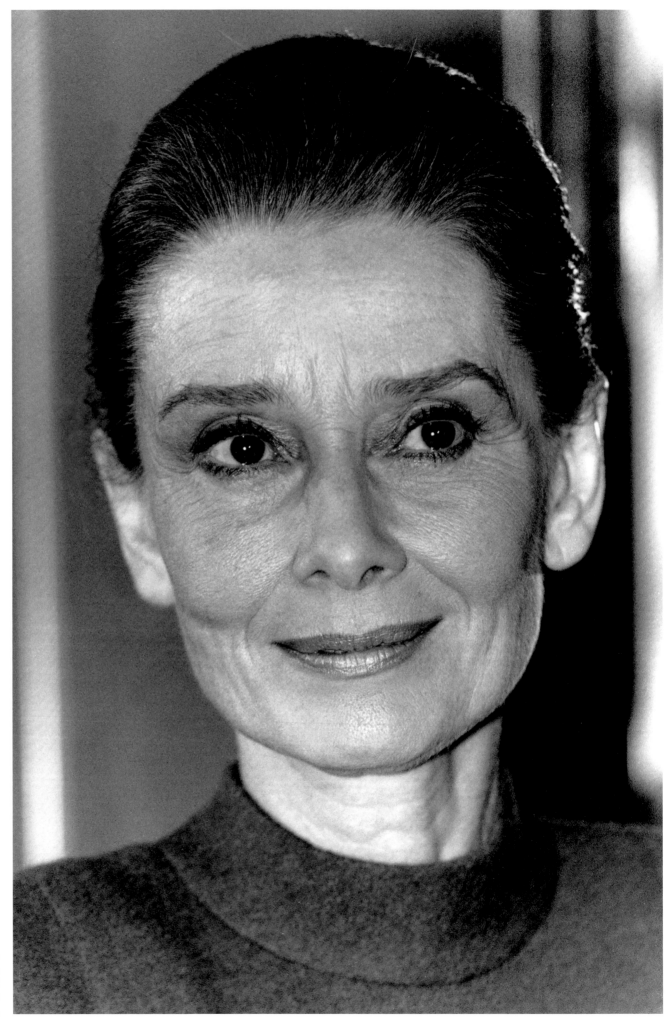

1989 / Paris, France / Audrey agrees to become an ambassadress for UNICEF, throwing herself headlong into a role that totally absorbs her.

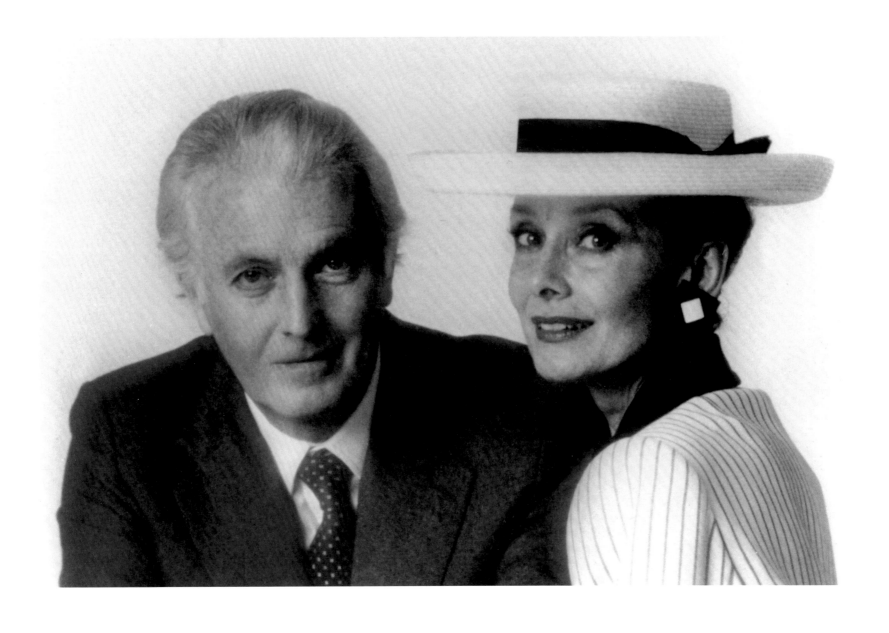

1983 / Paris, France / Audrey with Hubert de Givenchy in his boutique on the Avenue Montaigne. Their intimate bond was far more than a relationship between designer and star client and lasted more than 40 years.

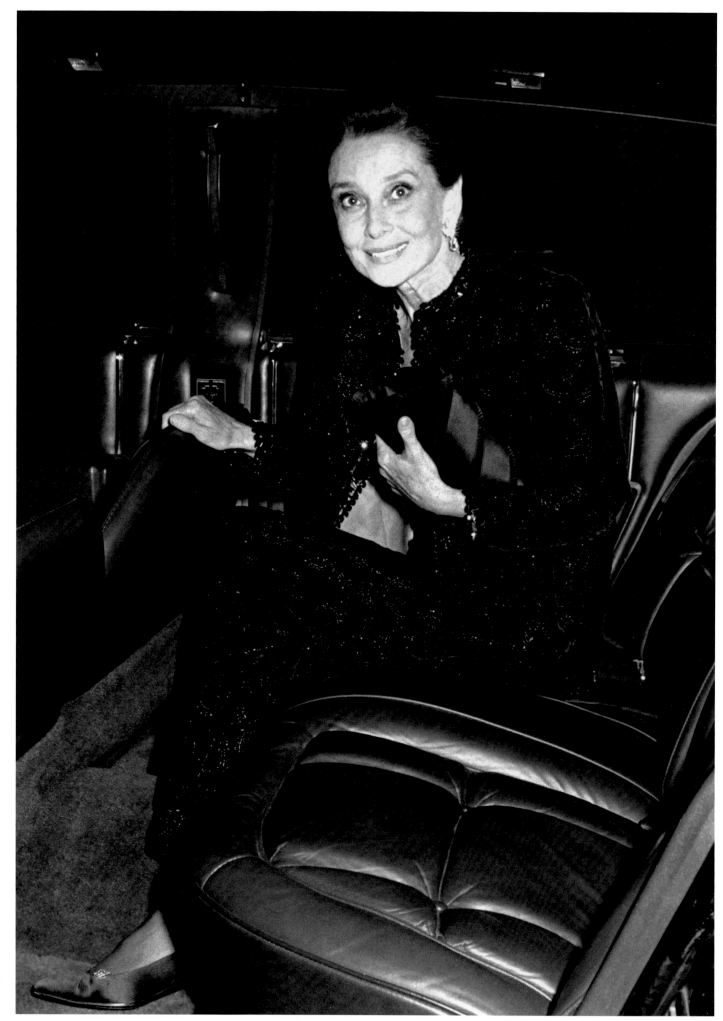

1988 / New York City /
Audrey arrives at a
charity gala.

184

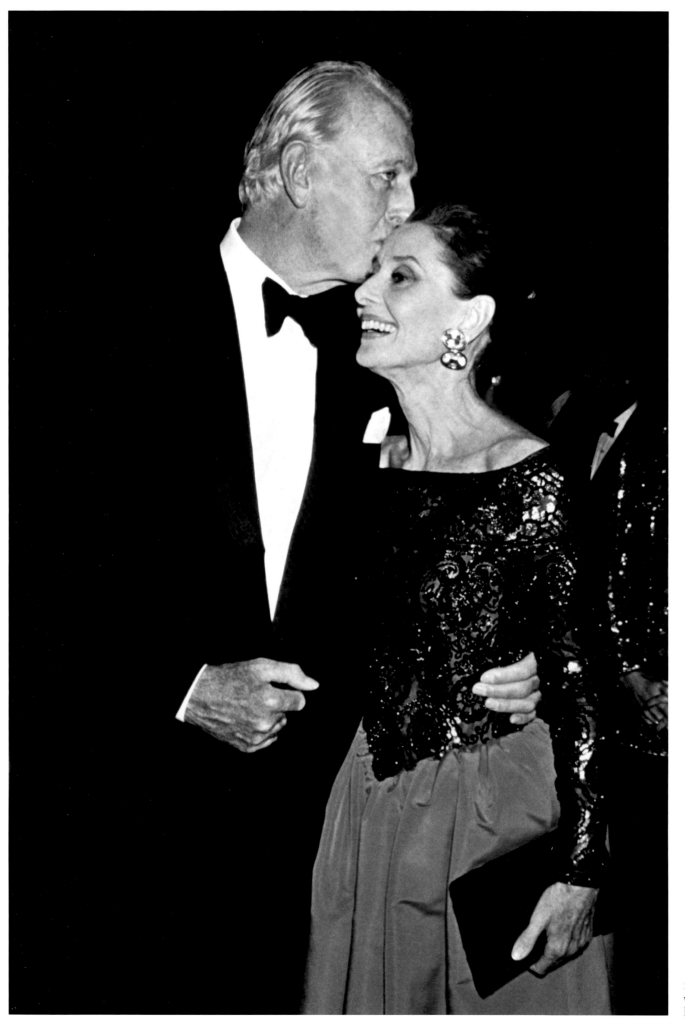

1988 / New York City / Audrey is welcomed to a party by close friend Hubert de Givenchy.

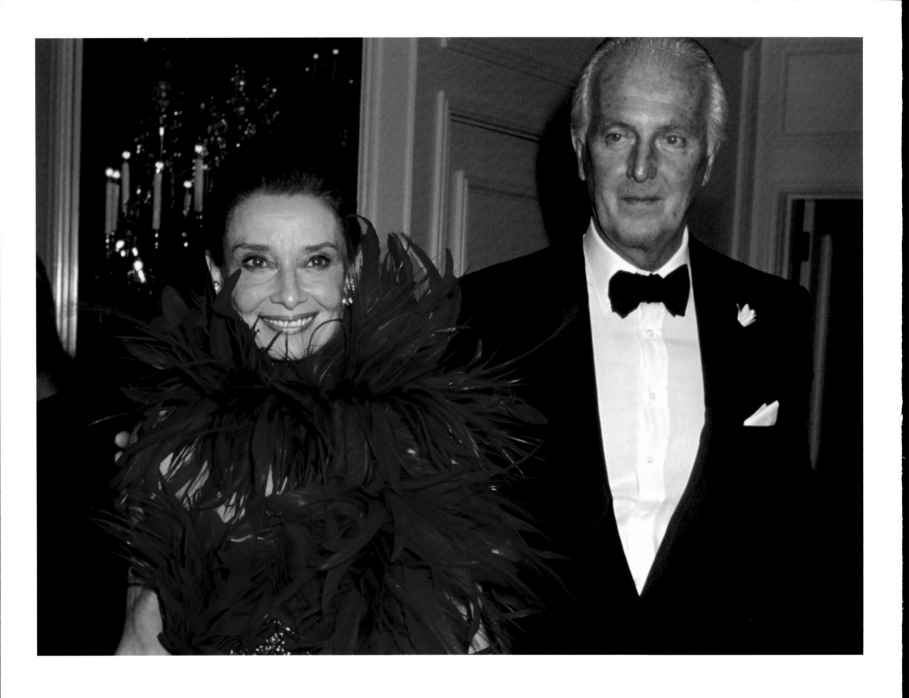

1990 / New York City / Audrey and Hubert de Givenchy.

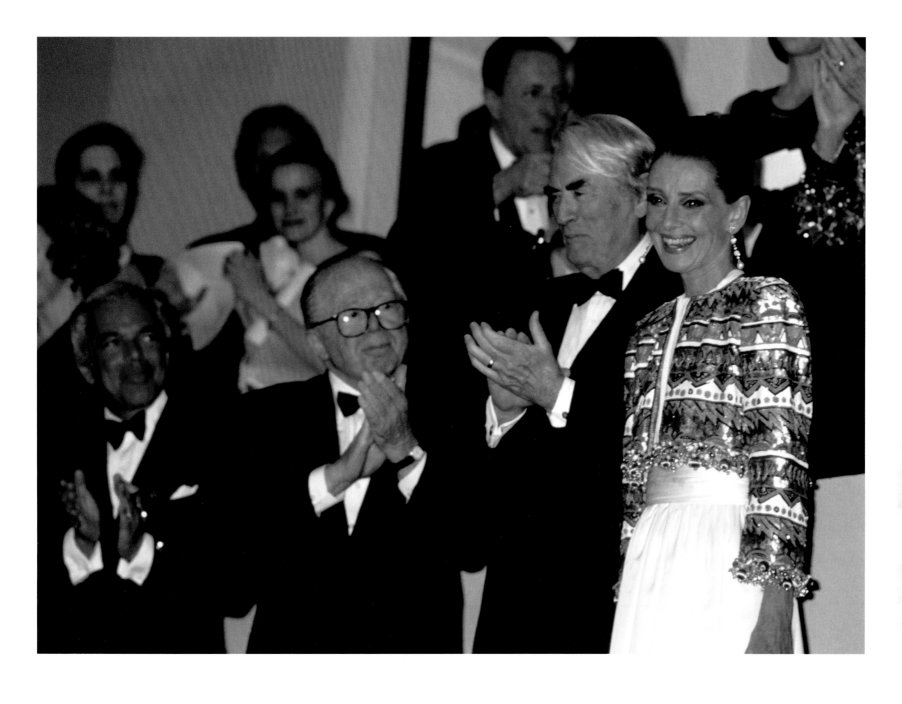

1990 / Los Angeles, CA / The Golden Globe ceremony: Audrey receives the Cecil B. DeMille Award for her lifetime's achievement.

« She was an enchantress, inspiring love and beauty. And fairies never quite disappear altogether.»

Hubert de Givenchy

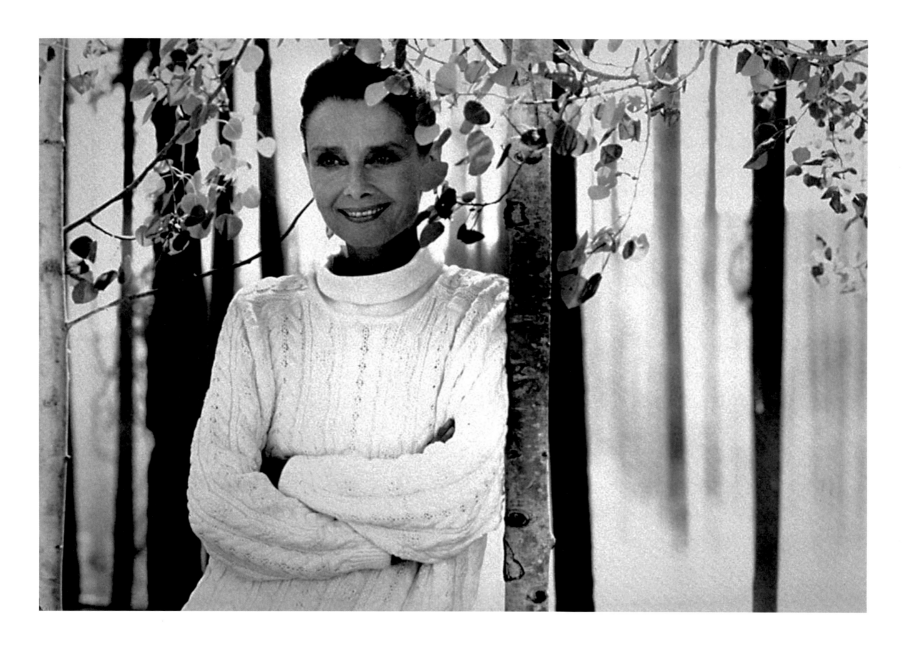

1989 / In her final movie, *Always*, directed by Steven Spielberg, Audrey played an angel.

Filmography

Always (1989)

Love Among Thieves (1987 - TV)

They All Laughed (1981)

Bloodline (1979)

Robin and Marian (1976)

Wait Until Dark (1967)

Two for the Road (1967)

How to Steal a Million Dollar (1966)

My Fair Lady (1964)

Paris - When It Sizzles (1964)

Charade (1963)

The Children's Hour (1961)

Breakfast at Tiffany's (1961)

The Unforgiven (1960)

The Nun's Story (1959)

Green Mansions (1959)

Love in the Afternoon (1957)

Producers' Showcase (TV - 1 episode in 1957)

Mayerling (1957 - TV)

Funny Face (1957)

War and Peace (1956)

Sabrina (1954)

Roman Holiday (1953)

Rainy Day in Paradise Junction (TV - 1952)

The Secret People (1952)

Nous irons à Monte Carlo (1951)

Young Wives' Tale (1951)

The Lavender Hill Mob (1951)

Laughter in Paradise (1951)

One Wild Oat (1951)

Monte Carlo Baby (1951)

Acknowledgements

Mounia, this book is for you.
At your side, happiness is simple, obvious, magical, ever-present.
And for the children: all the wild laughter and shared passions of days
to come …
Your man.

I would also like to thank:

M. Hubert de Givenchy, who so unhesitatingly opened his doors to me and so
spontaneously placed his pen at my disposal.
Listening to you describing your extraordinary friendship with Audrey was a
unique and moving experience.

Thomas Couteau, Edouard de Pouzilhac and Fabrice Fournier, who once again
rallied to the cause, assisting in my passion for books and photography.

Ron and Betty Galella, Carmen Masi, Barbara Mazza, Michèle Riesenmey,
Michael Schulman and Catherine Terk, for their invaluable aid in researching
the photos.

Yann-Brice Dherbier.

Credits